POSTCARD HISTORY SERIES

Santa Barbara
American Riviera
IN VINTAGE POSTCARDS

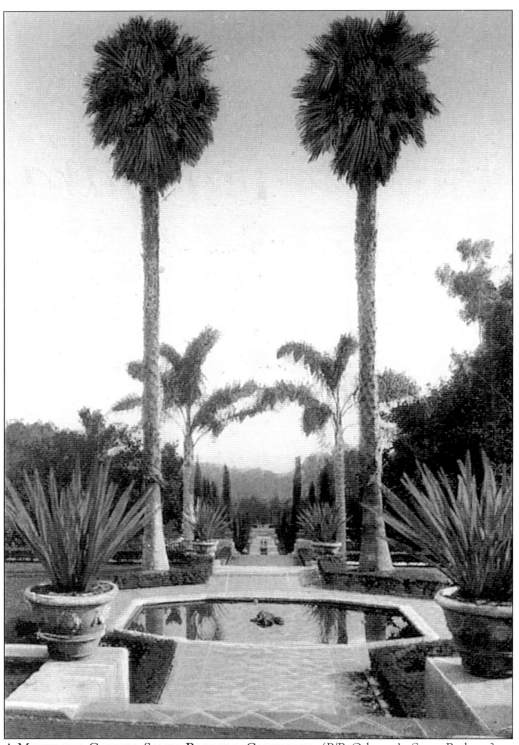

A Montecito Garden, Santa Barbara, California. (P/P: Osborne's, Santa Barbara.)

POSTCARD HISTORY SERIES

Santa Barbara
American Riviera
in Vintage Postcards

Marlin L. Heckman

ARCADIA

Copyright © 2000 by Marlin L. Heckman
ISBN 0-7385-0876-4

Published by Arcadia Publishing
Charleston SC, Chicago IL, Portsmouth NH, San Francisco CA

First published 2000
Reprinted 2005

Printed in Great Britain

Library of Congress Catalog Card Number: 00100163

For all general information contact Arcadia Publishing at:
Telephone 843-853-2070
Fax 843-853-0044
E-Mail sales@arcadiapublishing.com

For customer service and orders:
Toll-Free 1-888-313-2665

Visit us on the internet at http://www.arcadiapublishing.com

*All images in this book are from the author's personal collection,
including several cards that were gifts from Dana Johansen of La Verne, California.*

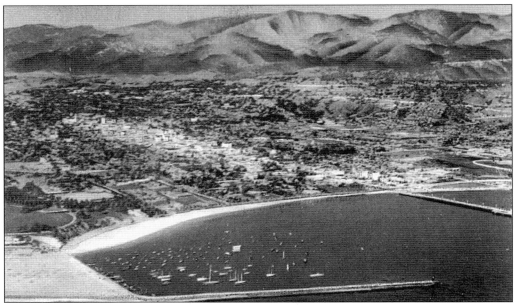

AIRVIEW OF SANTA BARBARA, CALIFORNIA. The inscription reads, "In this, the American Riviera, a New World city with an Old World charm, one will find a variety of historic and civic attractions, combined with unsurpassed facilities for one's favorite sporting pastimes." (P/P: Longshaw Card Co., Los Angeles, No. SB 9.)

Contents

Introduction		7
1.	Santa Barbara Mission	9
2.	Santa Barbara Resorts and Hotels	19
3.	Santa Barbara Earthquake	47
4.	Santa Barbara's Public Buildings and Spaces	55
5.	Santa Barbara Area Residences	71
6.	Santa Barbara Beaches and Views	89
7.	Santa Barbara County Places and Sights	107
Dedication		127
Index of Publishers and Photographers		128

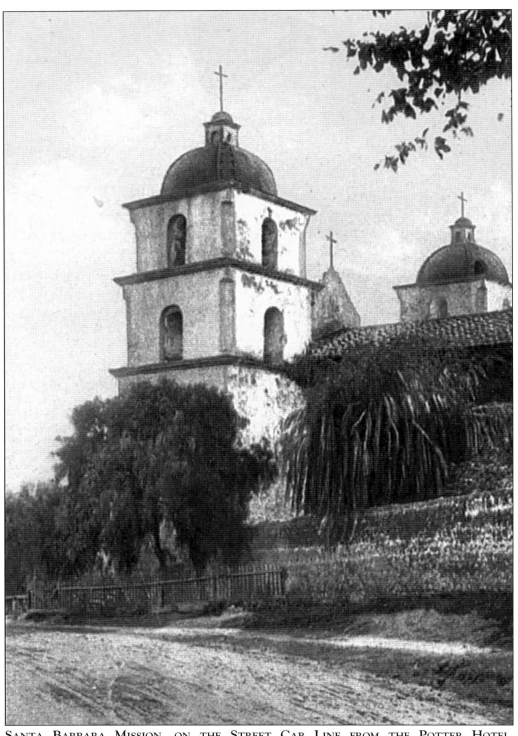

Santa Barbara Mission, on the Street Car Line from the Potter Hotel.
(P/P: Detroit Publishing Co., No. 7877; postmark: September 1911.)

INTRODUCTION

The area known today as Santa Barbara is a south-facing crescent of land between the Santa Ynez mountains and the Pacific Ocean, about 90 miles north of Los Angeles. It has been a favored spot for more than 300 years. A writer in *Harper's Weekly* gave the following description: " Santa Barbara, looking from the sea, presents a picture wherein ocean, mountains, fields and flower-bordered pathways are beautifully commingled…As the eye sweeps over it all, one feels that nature has designed here a spot where perfection is closely approached, and had then raised a barrier of mountains as if to afford protection from the disturbing contact of the other world." [*Harper's Weekly*, 48 (April 2, 1904): 508.]

The Cumash Indians called this area home for 200 years before the Portuguese navigator, Juan Rodriguez Cabrillo, discovered the Channel Islands off the coast in 1542. A century later, in 1642, the land was named in honor of Santa Barbara on her feast day, December 4^{th}. In 1786 Spanish Franciscans, led by Father Junipero Serra, chose Santa Barbara as the site for the tenth of the Spanish missions to be established along the California coast. Known as the "Queen of the Missions," Mission Santa Barbara was established on December 4, 1786. The present church was built in 1820, rebuilt after the earthquake of 1925, and restored again in 1953. It is the only mission with two towers. The Moorish fountain in front of the mission was built in 1808. A garden of more than 1000 roses grows in front of the fountain.

After years under the Spanish crown, Santa Barbara became the territory of Mexico. The area was claimed for the United States by General John C. Fremont in 1846. This brought an end to the Mexican period, and Santa Barbara became an American city on April 5, 1850.

In 1887 Santa Barbara streets were lit with electricity, and the first phone company had been established. Describing an earlier trip to Santa Barbara, Edward Roberts wrote the following in 1887: "There are two ways of reaching Santa Barbara from Los Angeles. One may go by boat up the coast or by train to Newhall, and from there overland by stage, which makes daily trips to and from Santa Barbara." [*Harpers Magazine* 75 (November, 1887): 814.]

The train was extended from Los Angeles to Santa Barbara in 1887 and on to San Francisco in 1901. By 1904 a writer in *Harpers Weekly* could say, "Four trains daily each way bring Santa Barbara into direct touch both with San Francisco and with Los Angeles. This fact has developed Santa Barbara a new feature, as she is rapidly becoming the Mecca for visitors from her own as well as from other states." [*Harpers Weekly* 48 (April 2, 1904): 504.]

Santa Barbara's weather has always drawn visitors, especially those from colder climates. Writing in *Country Life* in 1920, Charles Cushing said, "How ever earnestly one might desire to

be original, it is almost a journalistic impossibility to write about California and not mention the weather." [38 (July 1920): 57.] Cushing quoted Richard Dana, from *Two Years Beyond the Mast*: "Day after day," he recorded, "the sun shone clear and bright upon the wide bay and the red roofs of the houses, everything being as still as death, the people hardly seeming to earn their sunlight. Daylight was thrown away upon them." [Charles P. Cushing, "Country Clubs of America VII: Santa Barbara Country Club," *Country Life*, 38 (July 1920): 57.]

Two early resort hotels, the Arlington and the Potter, had been built to provide for winter stays for visitors who came to enjoy the sunshine. Many visitors claimed improved health during visits to Santa Barbara, and its fame as a health resort spread. After the loss of the Potter Hotel in 1921 and the Arlington in 1925, accommodations for the rich were only available at the Mirasol, the Sammarkand, the Miramar, and numerous less prestigious resorts and hotels.

Famous visitors to Santa Barbara have included the king and queen of Belgium, Princess Louise (daughter of Queen Victoria), and American Presidents Harrison, McKinley, and Theodore Roosevelt, among others.

After spending time in Santa Barbara, a number of visitors, drawn by the scenery and the weather, decided to become permanent residents, constructing many mansions and luxurious estates in neighboring Montecito. Later, large residences were also built in the Hope Ranch area of Santa Barbara. Thomas W. Hope had been a government appointed Indian agent. He was granted Las Positas y Calera land (Thomas Robbin's Ranch) by President U.S. Grant in July 1870. It has since been known as Hope Ranch.

Early in the morning of June 29, 1925, an earthquake leveled much of the city, resulting in 12 deaths. As the city was rebuilt, the Architectural Board of Review limited public buildings to no more than four stories, and residences were limited to three stories or less. Buildings in the downtown area were all built in Mediterranean style with red-tile roofs and plaster walls of a common color.

Santa Barbara remains a popular destination for tourists. Preservationists have helped contain growth and preserve the beauty of buildings and landscape. The citizens of Santa Barbara heeded the call of persons like preservationist and author Charles F. Lummis, who wrote in the Santa Barbara *News-Press* in 1933:

"Stand fast, Santa Barbara! Do not let selfish men or greedy interests skin Santa Barbara of her romance! Romance has been California's greatest asset for over 350 years. To all this centuried romance, Santa Barbara is the legitimate and favorite heiress….

The worst curse that could befall Santa Barbara would be the craze to GET BIG!…

It is up to you to save Santa Barbara…and set her mark as the most beautiful, the most artistic, the most distinguished and the most desirable little city on our Pacific Coast. She can be, if you will, for she has the makings. Stand fast, Santa Barbara!"

One
Santa Barbara Mission

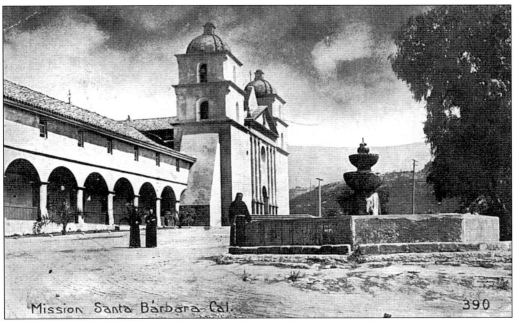

Santa Barbara Mission, California. This mission is known as the Queen of the Missions. (P/P: Edward H. Mitchell, San Francisco, No. 390; postmark: October 1911.)

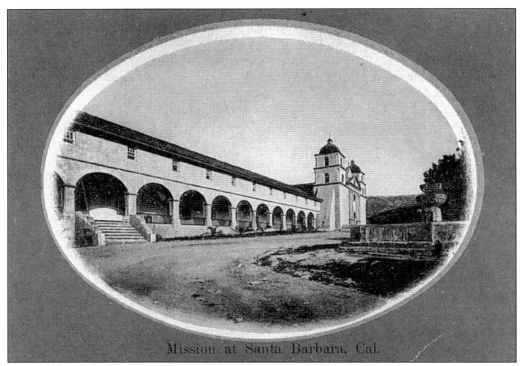

MISSION AT SANTA BARBARA, ESTABLISHED 1786. (P/P: Newman Postcard Co., Los Angeles, No. 9154.)

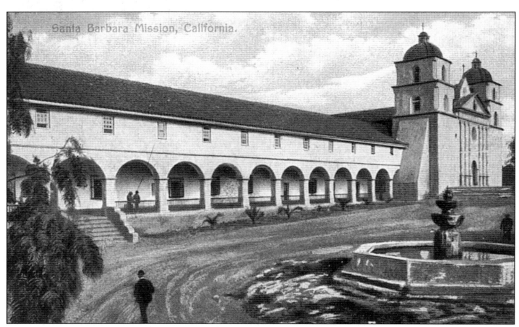

SANTA BARBARA MISSION. "One of the best known missions in Southern California." (P/P: Newman Postcard Co., Los Angeles, No. 29; made in Germany.)

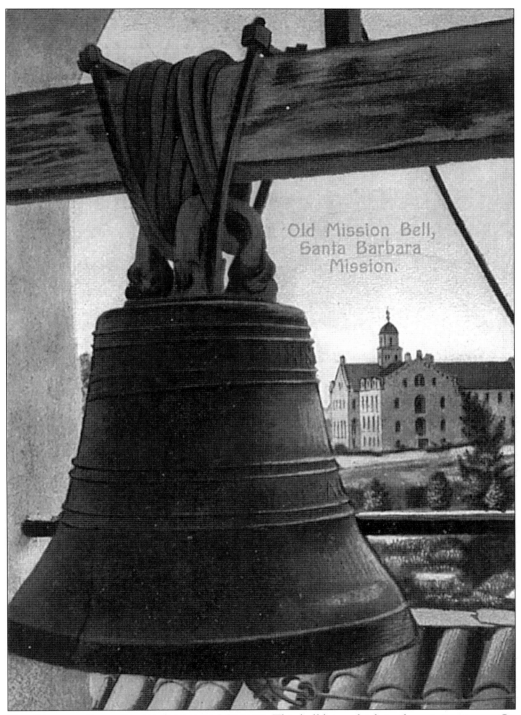

OLD MISSION BELL, SANTA BARBARA MISSION. This bell hangs high in the mission tower. St. Anthony's College is visible in the distance. (P/P: Newman Postcard Co., Los Angeles, No. Z 20; made in Germany.)

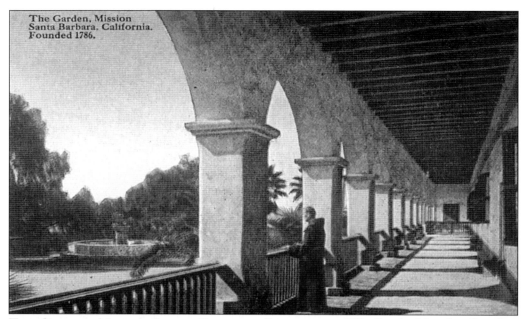

THE GARDEN, MISSION SANTA BARBARA, CALIFORNIA. (P/P: Pacific Novelty Co., San Francisco and Los Angeles, No. Z 106.)

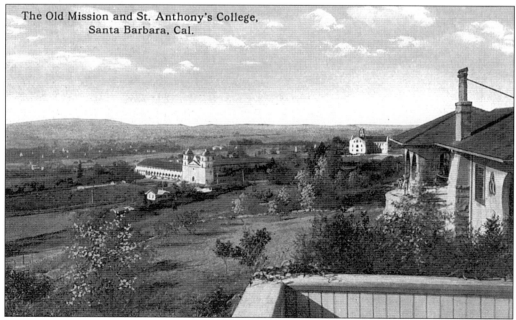

THE OLD MISSION AND ST. ANTHONY'S COLLEGE, SANTA BARBARA, CALIFORNIA. (P/P: Carlin Post Card Co., Los Angeles, No. 13932; made in the USA.)

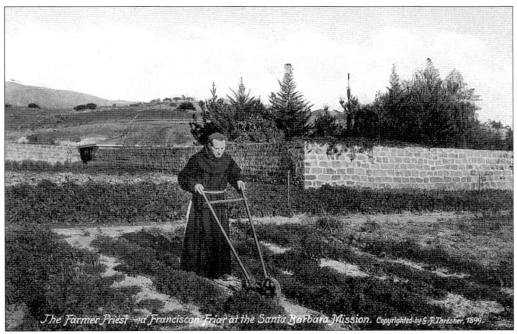

THE FARMER PRIEST–A FRANCISCAN FRIAR AT THE SANTA BARBARA MISSION. (P/P: M. Rieder, Los Angeles, No. 4222; made in Germany; copyrighted by S.P. Thresher, 1899.)

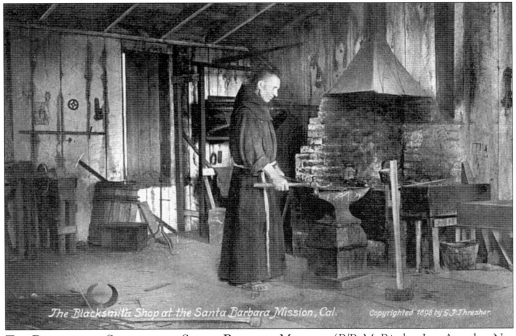

THE BLACKSMITH SHOP AT THE SANTA BARBARA MISSION. (P/P: M. Rieder, Los Angeles, No. 4219; made in Germany; copyrighted 1899 by S.P. Thresher.)

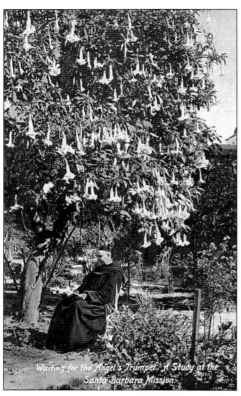

WAITING FOR THE ANGEL'S TRUMPET—A STUDY AT THE SANTA BARBARA MISSION. (P/P: M. Rieder, Los Angeles, No. 3666; made in Germany; postmark: December 1911.)

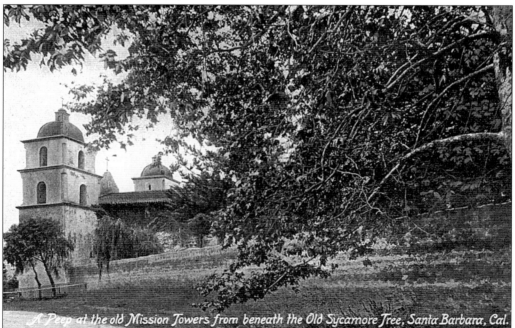

A PEEP AT THE OLD MISSION TOWERS FROM BENEATH THE OLD SYCAMORE TREE, SANTA BARBARA. (P/P: M. Rieder, Los Angeles and Leipzig, No. 3592; made in Germany.)

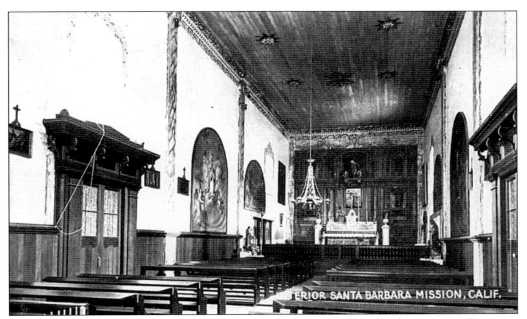

INTERIOR SANTA BARBARA MISSION, CALIFORNIA. (P/P: Pacific Novelty Co., San Francisco and Los Angeles.)

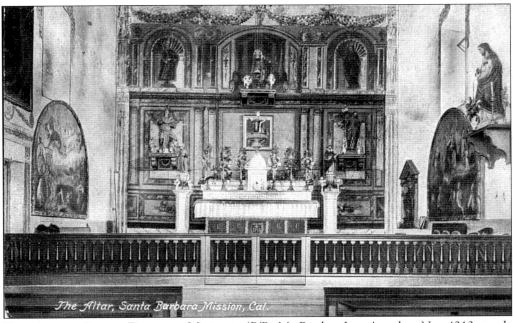

THE ALTAR, SANTA BARBARA MISSION. (P/P: M. Rieder, Los Angeles, No. 4213; made in Germany.)

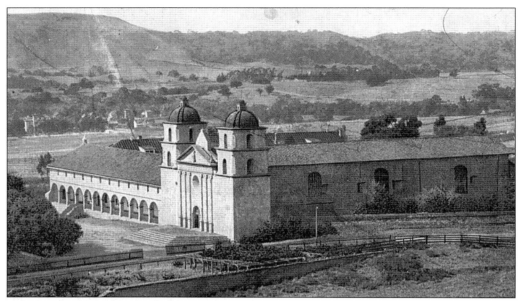

SANTA BARBARA MISSION, CALIFORNIA. This view shows the beautiful setting against the hills with a garden in the foreground. (P/P: Detroit Publishing Co., No. 7811; printed in Switzerland; postmark: June 1910.)

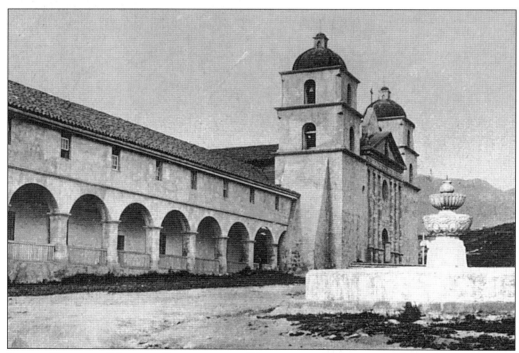

SANTA BARBARA MISSION, SHOWING THE TOWERS AND FOUNTAIN. The message from the sender reads, "Please don't write so soon again." (P/P: E.P. Charlton & Co., Los Angeles; undivided back; postmark: June 1906.)

FATHER SUPERIOR, AT FOUNTAIN IN HOLY GARDEN, MISSION SANTA BARBARA. (P/P: Tichnor Bros, Boston and Los Angeles, No. 918.)

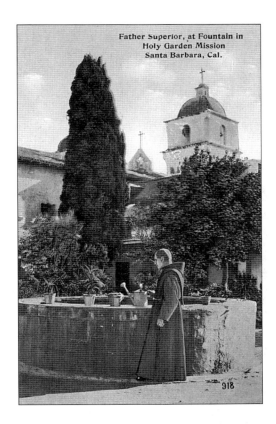

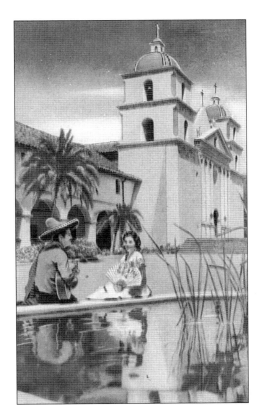

FIESTA DAYS AT SANTA BARBARA MISSION. "A gay caballero and his senorita pause in the merry-making of the Fiesta to rest beside the fountain in front of the beautiful age-old mission at Santa Barbara." (P/P: Longshaw Card Co., Los Angeles, No. SB 3.)

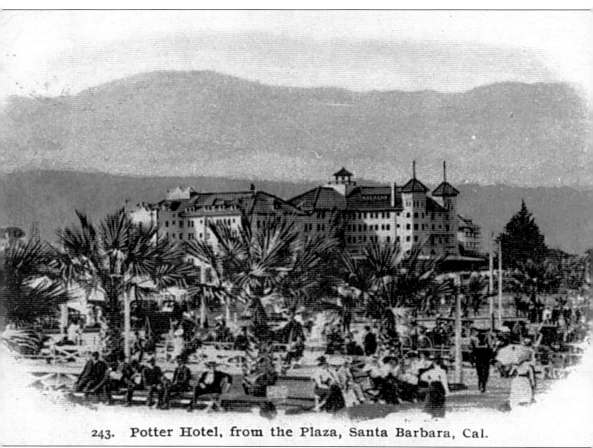

243. Potter Hotel, from the Plaza, Santa Barbara, Cal.

POTTER HOTEL FROM THE PLAZA. This view of Santa Barbara shows people enjoying the beach promenade with palms and mountains in the background. (P/P: Art Litho Co., San Francisco, No. 243; postmark: December 1907.)

Two
Santa Barbara Resorts and Hotels

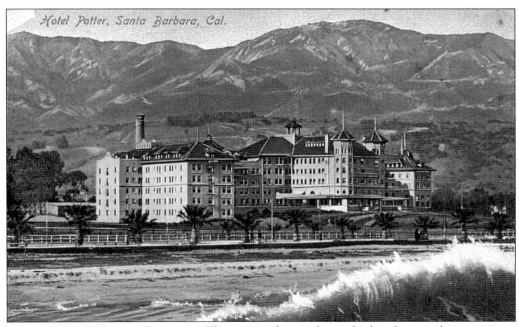

POTTER HOTEL, SANTA BARBARA. This postcard view shows the hotel in its glorious oceanside setting against the mountain backdrop. (P/P: Newman Postcard Co., Los Angeles, No. M 61; made in Germany; handwritten date: 1909.)

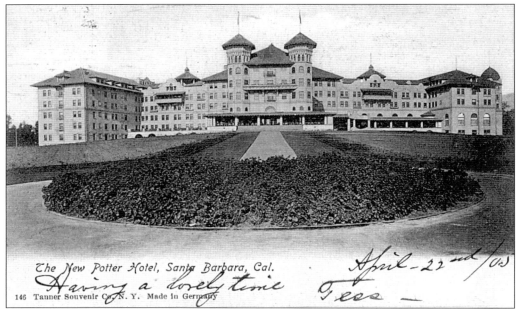

THE NEW POTTER HOTEL, SANTA BARBARA. Here is an early view of the Potter with flower circle in front. (P/P: Tanner Souvenir Co., New York, No. 146; made in Germany; undivided back; postmark: April 1905.)

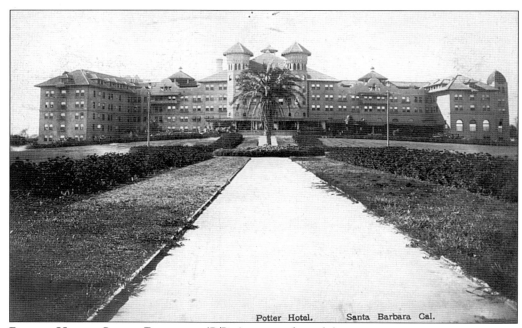

POTTER HOTEL, SANTA BARBARA. (P/P: Artura trademark.)

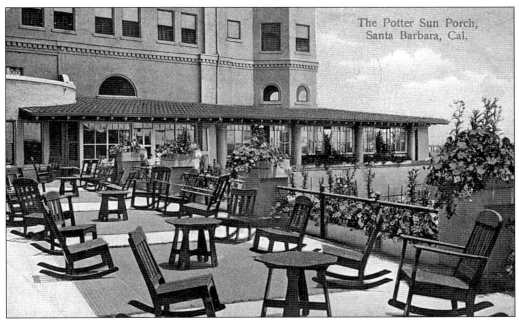

THE POTTER SUN PORCH, SANTA BARBARA. The inscription reads, "[We] are at this hotel—700 rooms, magnificent…Beautiful surf. The ocean is a stone's throw from our room." (P/P: M. Rieder, Los Angeles, No. 4486; made in Germany; postmark: January 1908.)

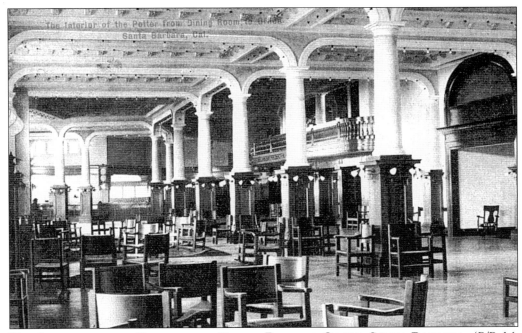

THE INTERIOR OF THE POTTER FROM DINING ROOM TO OFFICE, SANTA BARBARA. (P/P: M. Rieder, Los Angeles and Dresden, No. 9019.)

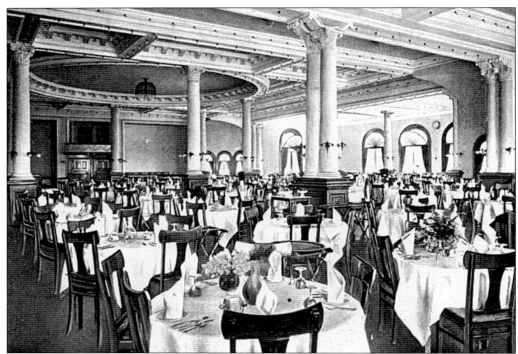

DINING ROOM OF THE POTTER HOTEL, SANTA BARBARA. (P/P: M. Rieder, Los Angeles; made in Germany.)

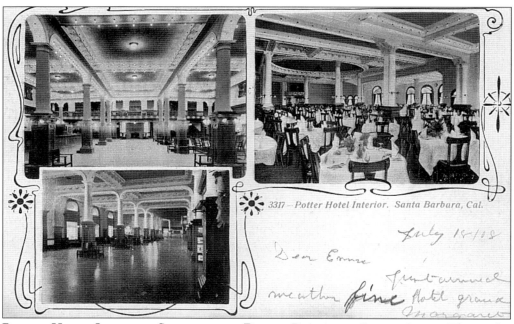

POTTER HOTEL INTERIOR, SHOWING THE DINING ROOM AND LOBBY AREAS. The sender wrote, "Just arrived. Weather fine. Hotel grand." (P/P: Adolph Selige, St. Louis, No. 3317; undivided back; postmark: July 1908.)

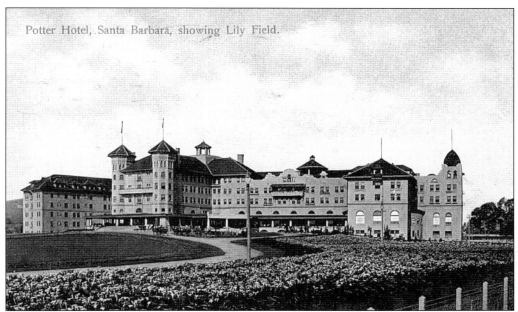

POTTER HOTEL, SHOWING LILY FIELD. (P/P: M. Rieder, Los Angeles and Leipzig, No. 3259.)

ENTRANCE TO THE POTTER HOTEL, SANTA BARBARA. (P/P: Detroit Publishing Co., No. 12204; copyright: 1907.)

BOUGANVILLA AT THE POTTER HOTEL, SANTA BARBARA. (P/P: Detroit Publishing Co., No. 13181.)

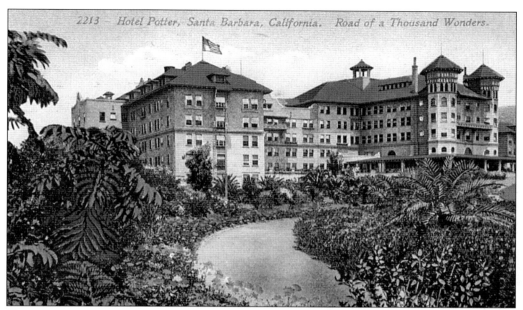

HOTEL POTTER, THE ROAD OF A THOUSAND WONDERS. This view shows the lush vegetation and flowers surrounding the hotel entrance. (P/P: Edward H. Mitchell, San Francisco, No. 2213.)

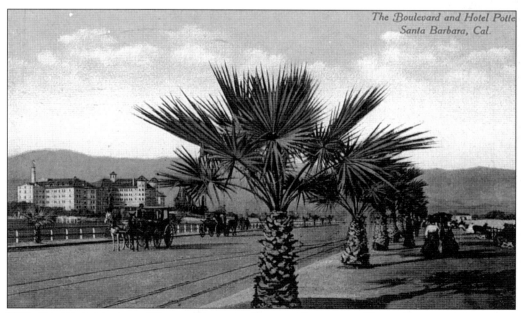

THE BOULEVARD AND HOTEL POTTER, SANTA BARBARA. Horse-drawn carriages and promenade walkers appear along the boulevard. (P/P: Newman Post Card Co., Los Angeles and San Francisco, No. M 7.)

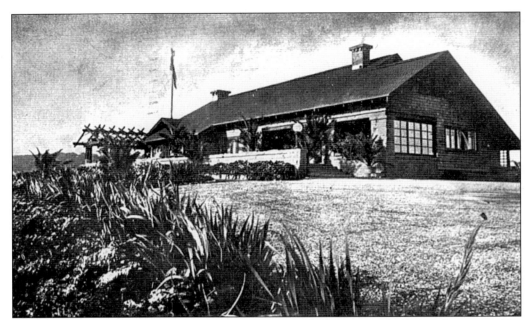

Potter Country Club, Santa Barbara. (P/P: Edward H. Mitchell, San Francisco, No. 357; postmark: January 1921.)

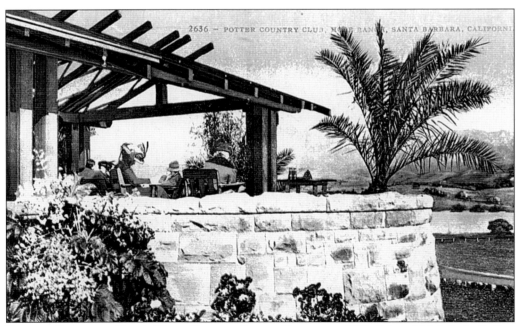

Potter Country Club, Hope Ranch, Santa Barbara. (P/P: Edward H. Mitchell, San Francisco, No. 2636; made in America.)

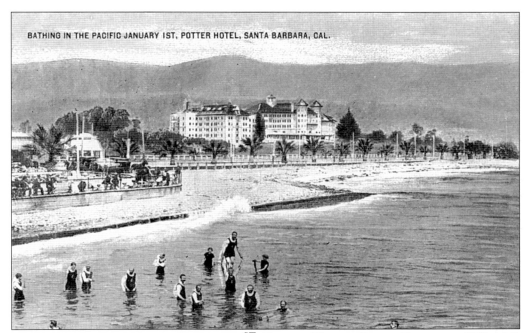

BATHING IN THE PACIFIC ON JANUARY 1ST, POTTER HOTEL, SANTA BARBARA. (P/P: M.F. Berkey, Santa Barbara.)

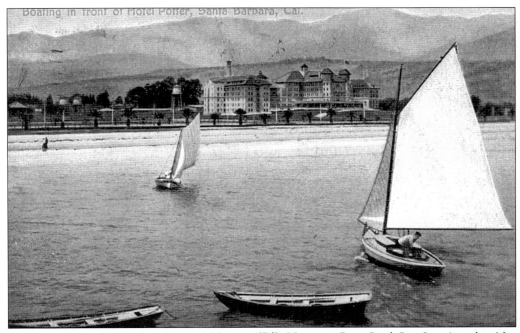

BOATING IN FRONT OF THE POTTER HOTEL. (P/P: Newman Post Card Co., Los Angeles, No. 6108; made in Germany; postmark: April 1908.)

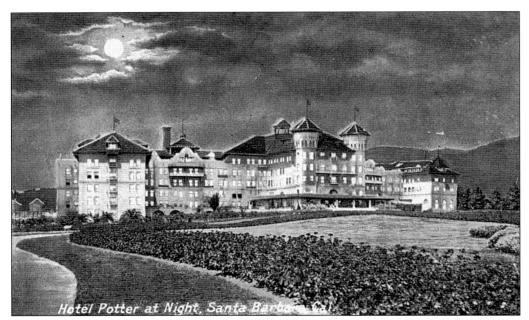

HOTEL POTTER AT NIGHT, SANTA BARBARA. (P/P: Newman Post Card Co., Los Angeles, No. M 60; made in Germany.)

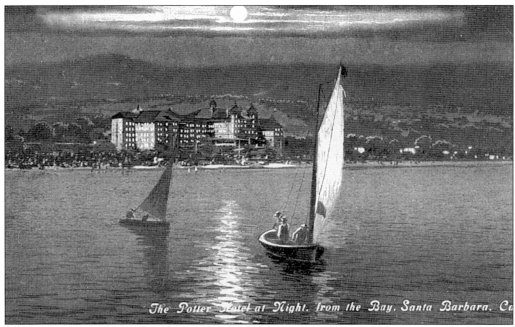

THE POTTER HOTEL AT NIGHT FROM THE BAY, SANTA BARBARA. (P/P: Carlin Post Card Co., Los Angeles, No. A 13927; made in the USA.)

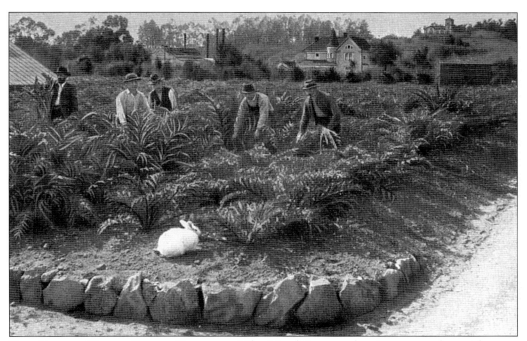

THE POTTER HOTEL, SANTA BARBARA. "The Hotel Potter… has its own gardens right near the Hotel where grow all the year round fresh vegetables such as pie plant, asparagus and like this splendid artichoke garden." (P/P: Newman Post Card Co., Los Angeles; made in Germany.)

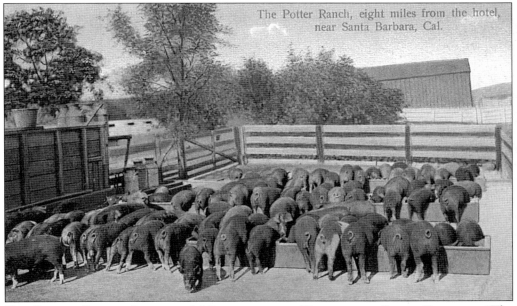

THE POTTER RANCH, LOCATED 8 MILES FROM THE HOTEL, NEAR SANTA BARBARA. "The hotel has ranches for supplying all suckling pigs, chickens, eggs, breeders, and fryers; a dairy for all milk, cream, butter, and cheese." (P/P: M. Rieder, Los Angeles, No. 4489; made in Germany.)

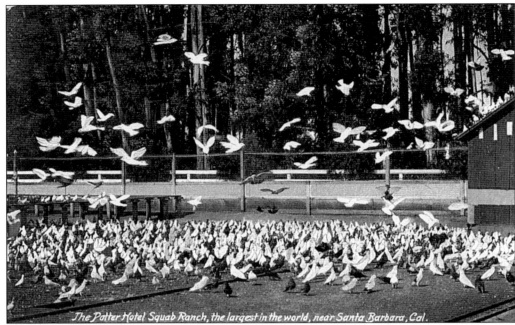

THE POTTER SQUAB RANCH, THE LARGEST IN THE WORLD, LOCATED NEAR SANTA BARBARA. More than 60,000 pigeons were raised on this ranch. (P/P: M. Rieder, Los Angeles, No. 4491; made in Germany.)

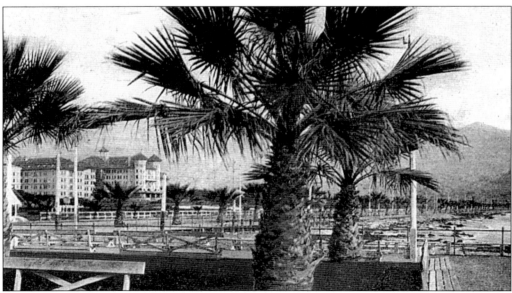

VIEW OF THE POTTER HOTEL FROM THE PLAZA DEL MAR, SANTA BARBARA. (P/P: M. Rieder, Los Angeles, No. 614; undivided back.)

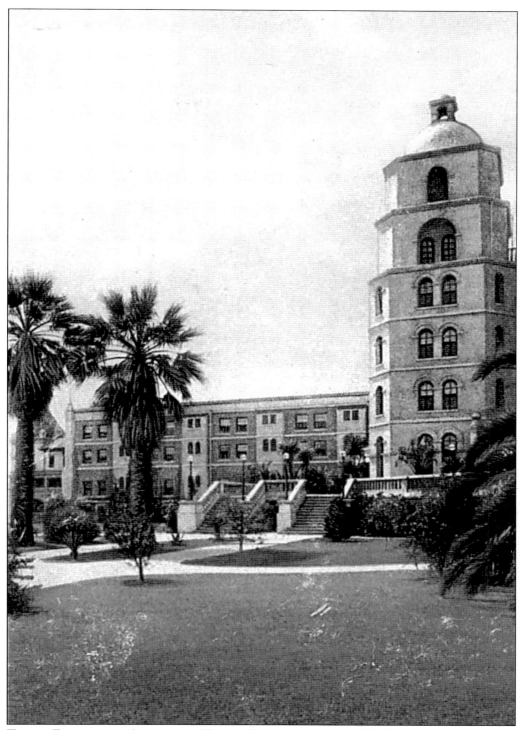

Tower End of the Arlington Hotel, Santa Barbara. (P/P: Detroit Publishing Co., No. 71677.)

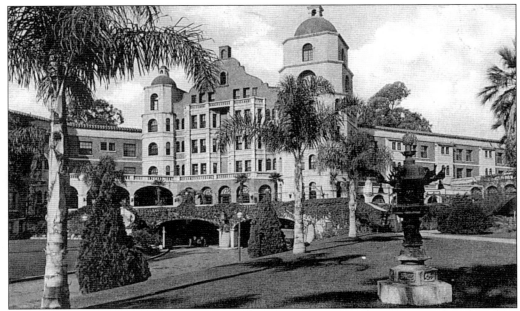

HOTEL ARLINGTON, SANTA BARBARA. Originally built in 1875 at a cost of $160,000, the Hotel Arlington had 90 guest rooms. (P/P: Western Publishing and Novelty Co., Los Angeles, No. 881; made in the USA.)

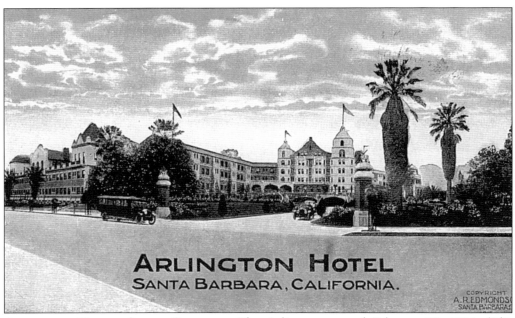

ARLINGTON HOTEL, SANTA BARBARA. The Arlington opened February 27, 1876. (P/P: E.C. Kropp Co., Milwaukee, Wisconsin, No. 16637; copyright: A.R. Edmundson, Santa Barbara, 1915.)

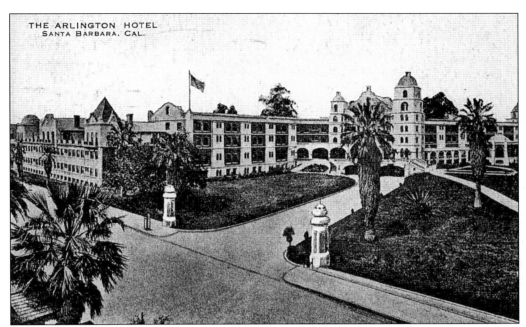

THE ARLINGTON HOTEL, SANTA BARBARA. The original building burned in 1908 and was rebuilt with brick and reinforced concrete in 1911. (P/P: Neuner Co., Los Angeles; postmark: March 1916.)

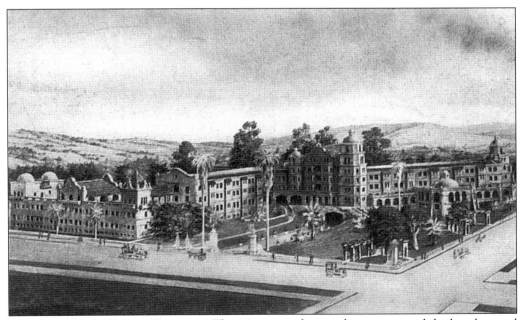

THE ARLINGTON, SANTA BARBARA. There is a story that southerners wanted the hotel named for Robert E. Lee and the northerners wanted it named for U.S. Grant. They compromised with the Arlington, the name of Lee's mansion in Virginia, which Grant had used. (P/P: California Sales Co., San Francisco.)

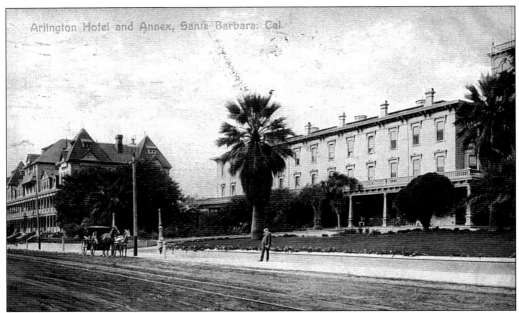

ARLINGTON HOTEL AND ANNEX, SANTA BARBARA. After the arrival of the railroad in 1887, the Arlington Annex was built. (P/P: Newman Post Card Co., Los Angeles, No. 6105; made in Germany; postmark: December 1908.)

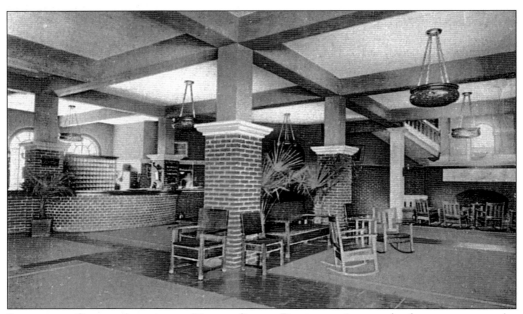

LOBBY AND OFFICE, ARLINGTON HOTEL, SANTA BARBARA. Among the famous guests at the Arlington were Princess Louise (dau. of Queen Victoria) and U.S. Presidents Harrison, McKinley, and Theodore Roosevelt. (P/P: Detroit Publishing Co., No. D 70883.)

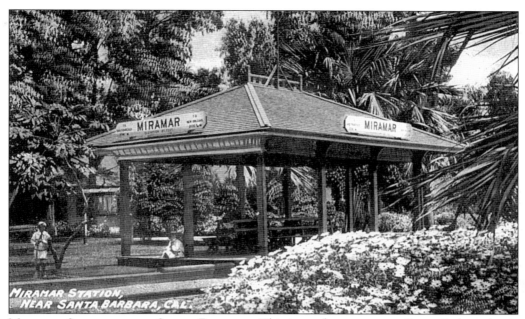

MIRAMAR STATION, NEAR SANTA BARBARA. This is another resort near Santa Barbara that is still operating. (P/P: M.F. Berkey, Santa Barbara.)

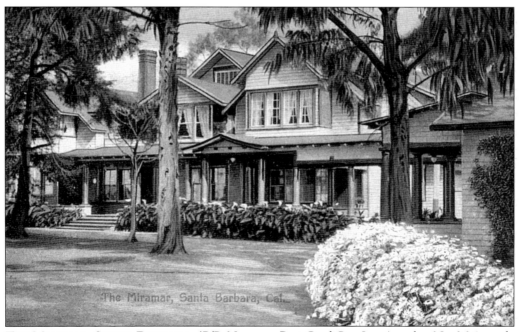

THE MIRAMAR, SANTA BARBARA. (P/P: Newman Post Card Co., Los Angeles, No. M 4; made in Germany.)

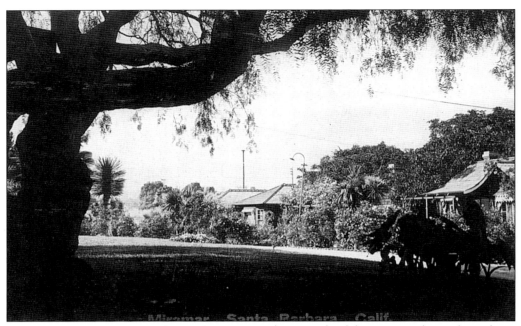

MIRAMAR GROUNDS, NEAR SANTA BARBARA. The grounds of the Miramar have always been a spectacular sight. (P/P: Brock Higgins Photo; Artura.)

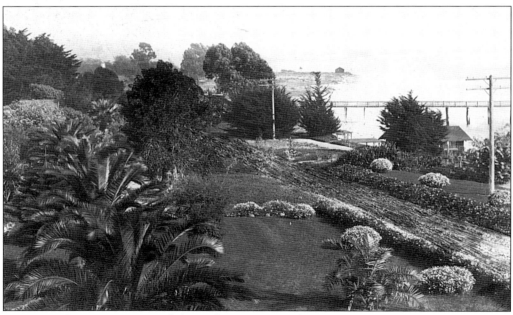

MIRAMAR, SANTA BARBARA. (P/P: Unknown; Artura.)

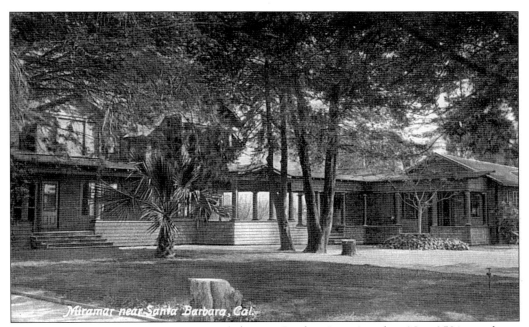

MIRAMAR, NEAR SANTA BARBARA. (P/P: M. Rieder, Los Angeles, No. 3591; made in Germany.)

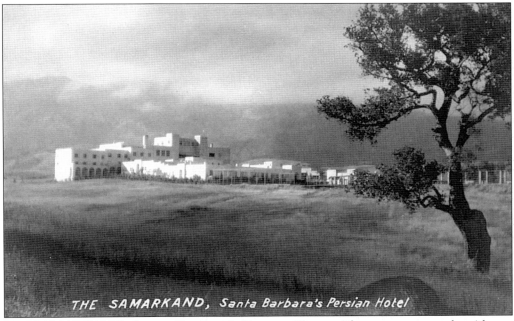

THE SAMARKAND, SANTA BARBARA'S PERSIAN HOTEL. The property was a boys' home from 1916 to 1918. It was then subdivided and opened as a resort hotel in 1920. It was renamed, the Samarkand, "land of heart's desire." (P/P: J.W. Collinge, Santa Barbara.)

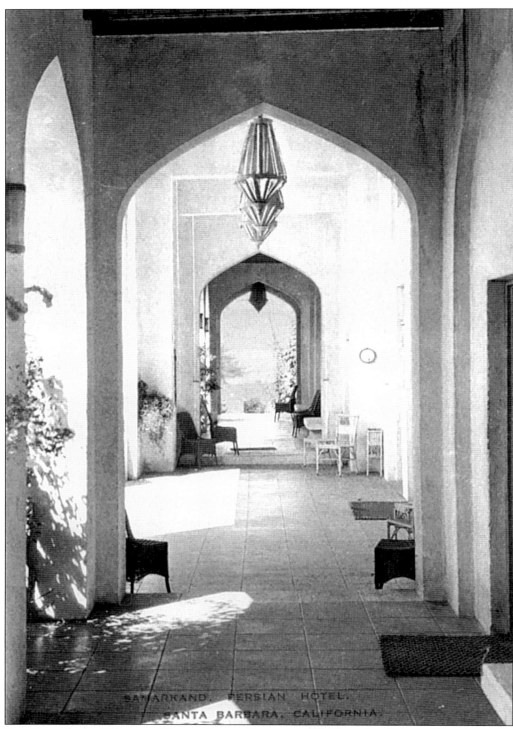

THE SAMARKAND, PERSIAN HOTEL, SANTA BARBARA. The Samarkand opened December 31, 1920, decorated in lavish Persian style. (P/P: W.W. Osborne, Santa Barbara.)

THE SAMARKAND, PERSIAN HOTEL, SANTA BARBARA. (P/P: Osborne's, Santa Barbara.)

SAMARKAND PERSIAN HOTEL, SANTA BARBARA. (P/P: Artura.)

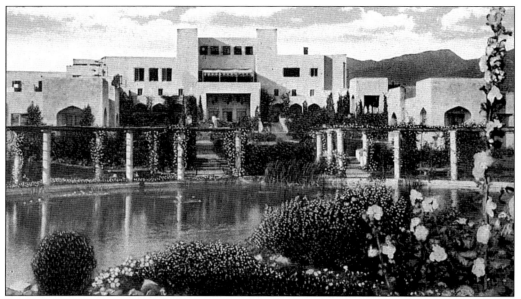

SAMARKAND PERSIAN HOTEL, SANTA BARBARA. (P/P: Western Novelty and Publishing Co., Los Angles, No. SB 76.)

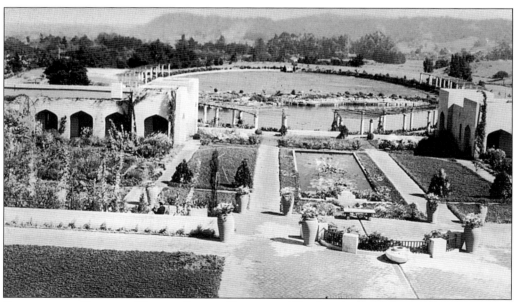

SAMARKAND, PERSIAN HOTEL, SANTA BARBARA. The hotel closed in 1954 and was later converted to a retirement complex, which has been operated by the Evangelical Covenant Church under the name, the Sammarkand, since the mid-1960s. (P/P: Artura; Date: handwritten, August 10, 1924.)

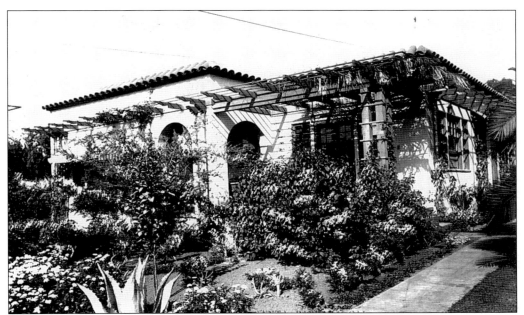

EL MIRASOL HOTEL, SANTA BARBARA. After the loss of the Potter Hotel in 1921 and the Arlington, in 1925, accommodations for the rich were available only at the Sammarkand and the Mirasol. (P/P: Artura.)

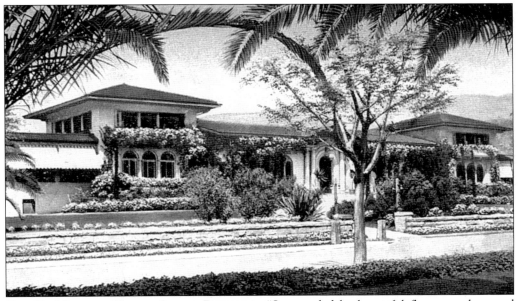

THE EL MIRASOL HOTEL, SANTA BARBARA. "Surrounded by beautiful flower gardens and facing the park, this hotel and attractive bungalows offer luxurious accommodations and is one of the show places of Santa Barbara." It was taken down in 1968. (P/P: M.F. Berkey, Santa Barbara, No. A 74557.)

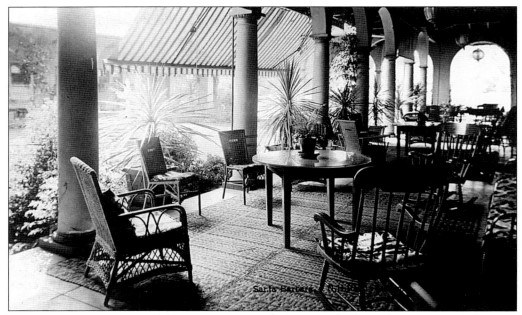

EL MIRASOL, SANTA BARBARA. Here is a nice place to spend a leisurely afternoon. (P/P: N.H. Reed Studio.)

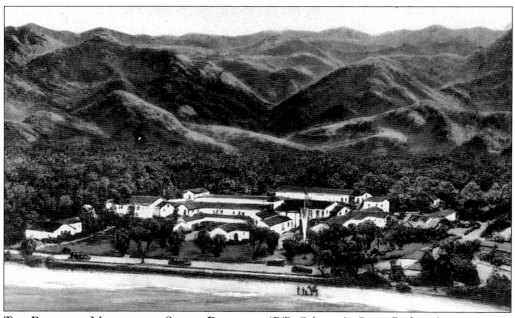

THE BILTMORE MONTECITO, SANTA BARBARA. (P/P: Osborne's, Santa Barbara.)

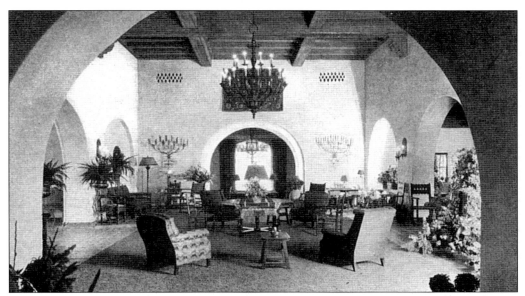

INTERIOR VIEW OF THE SANTA BARBARA BILTMORE. The interiors at Santa Barbara Biltmore are typically Spanish. (P/P: Neuner Printing & Lithograph, Los Angeles.)

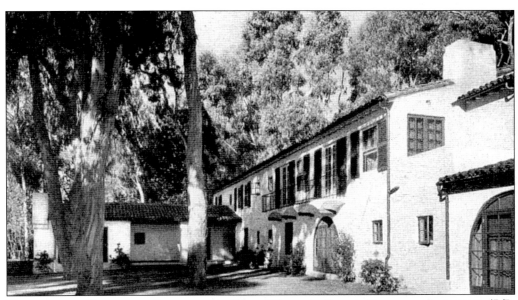

UMBRAGEOUS EUCALYPTI SHELTER THE WEST WING AT SANTA BARBARA BILTMORE. (P/P: Neuner Printing & Lithograph, Los Angeles.)

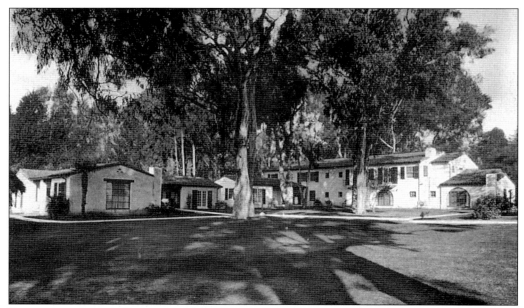

Bungalows, the Biltmore, Montecito, Santa Barbara. (P/P: Osborne's, Santa Barbara.)

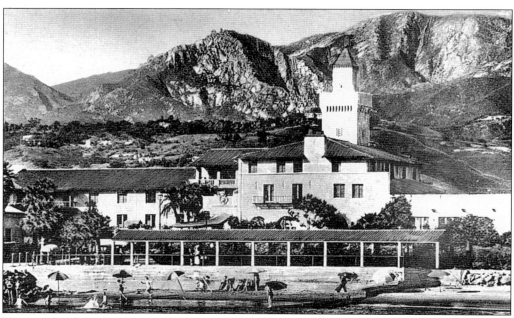

Hotel Mar Monte, Santa Barbara. (P/P: Osborne's, Santa Barbara.)

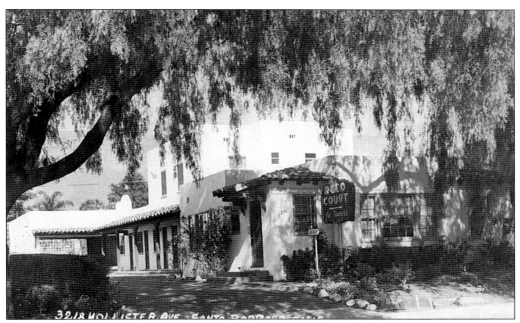

REED COURT, LOCATED AT 3218 HOLLISTER AVENUE, SANTA BARBARA. (P/P: Unknown.)

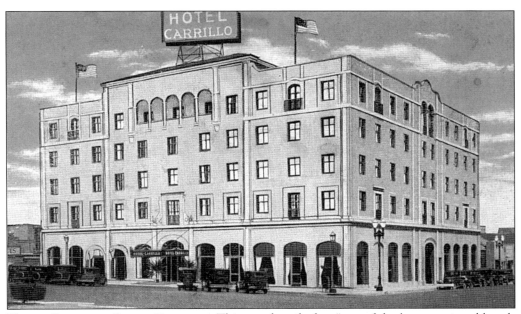

HOTEL CARRILLO, SANTA BARBARA. This was described as "one of the best appointed hotels on the Coast Highway." (P/P: Unknown; No. 12163.)

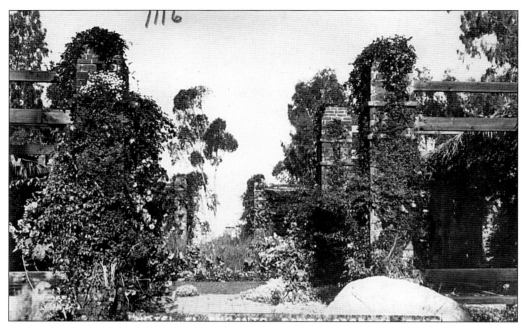

HOTEL EL ENCANTO, SANTA BARBARA. (P/P: Artura.)

HOTEL NEAL, SANTA BARBARA. (P/P: Albertype Co., Brooklyn, NY; postmark: November 1910.)

Three
Santa Barbara Earthquake

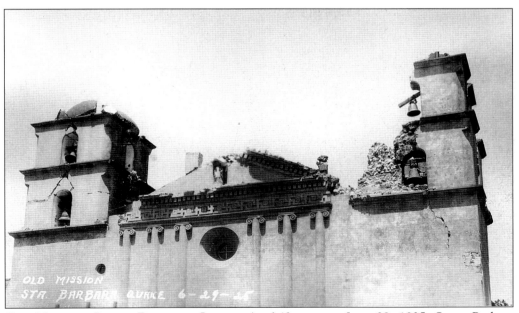

Old Mission, Santa Barbara Quake. At 6:42 a.m. on June 29, 1925, Santa Barbara experienced a violent earthquake. This image shows the quake's damage to the two bell towers. (P/P: Unknown; date: June 1925.)

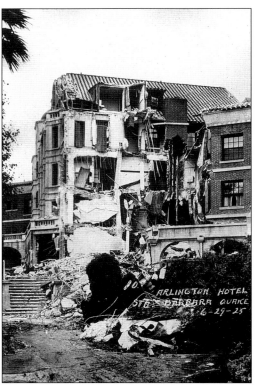

ARLINGTON HOTEL, SANTA BARBARA QUAKE. "It all happened in a minute. The crash of falling timber and steel beams and the walls of the hotel made an indescribable inferno of sound which dazed me," said hotel guest G. Allan Hancock in the Santa Barbara *News-Press* on July 2, 1925. (P/P: Unknown; date: June 1925.)

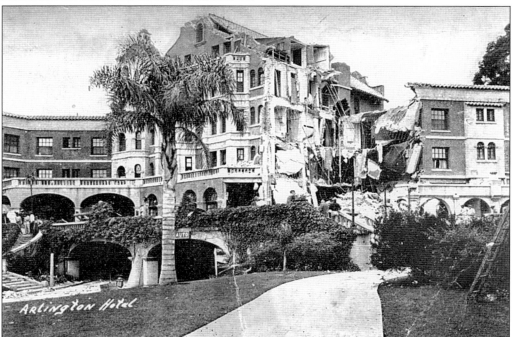

ARLINGTON HOTEL. (P/P: Press of Scherer Printing Studio for Ramona Bookstore; date: June 1925.)

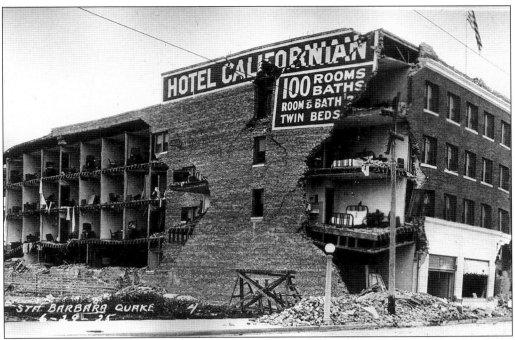

CALIFORNIAN HOTEL. The hotel had been open only four days before the quake. (P/P: Unknown; date: June 1925.)

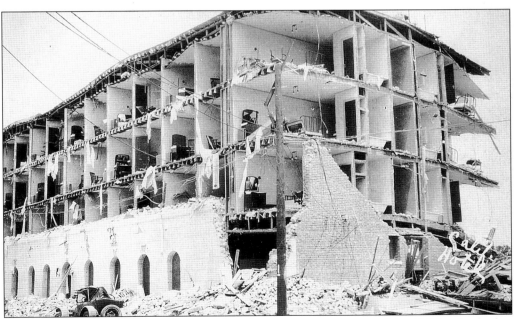

CALIFORNIAN HOTEL. Due to doors stuck in frames, some occupants of the Californian had to resort to lowering themselves to the street on bed sheets that were tied together. (P/P: Unknown; date: June 1925.)

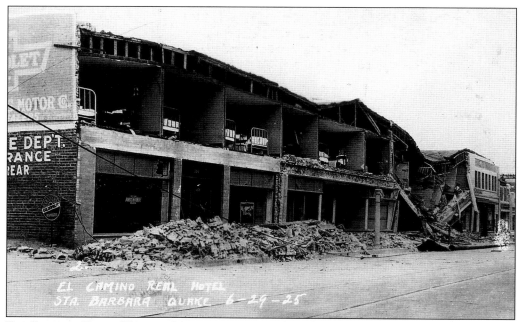

EL CAMINO REAL HOTEL, SANTA BARBARA QUAKE. An early-morning golfer on the LeCumbre Golf Course said, "The hills seemed to rise and fall—no, I was perfectly all right, no illusions you know—the rolling of the landscape being plainly visible on all sides of me. It was not the little jerks once in a while felt in many parts of the state, but a long drawn out roll that I believe would put many of our beach roller coasters into a class below it." (Santa Barbara *News-Press*, June 30, 1925.) (P/P: Unknown; date: June 1925.)

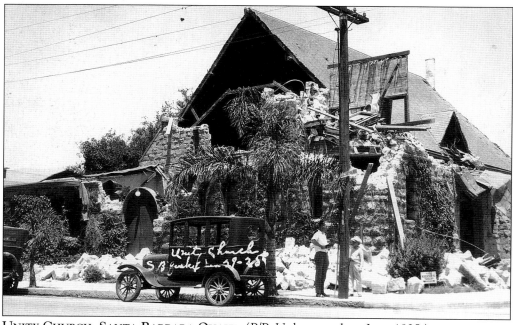

UNITY CHURCH, SANTA BARBARA QUAKE. (P/P: Unknown; date: June 1925.)

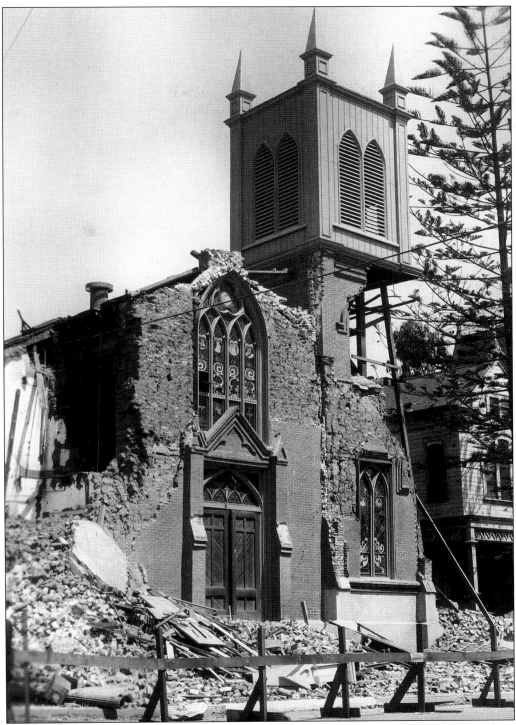
CHURCH OF OUR LADY OF SORROWS, SANTA BARBARA QUAKE. (P/P: Unknown; date: June 1925.)

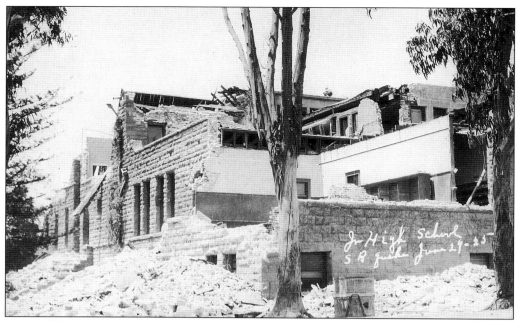

JUNIOR HIGH SCHOOL, SANTA BARBARA QUAKE. (P/P: Unknown; date: June 1925.)

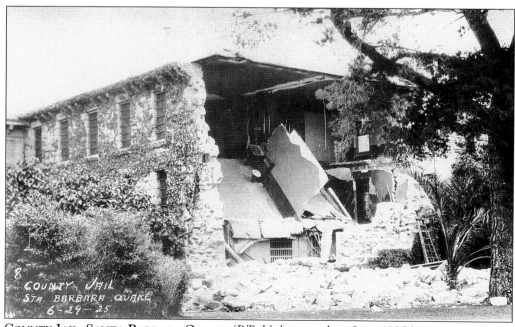

COUNTY JAIL, SANTA BARBARA QUAKE. (P/P: Unknown; date: June 1925.)

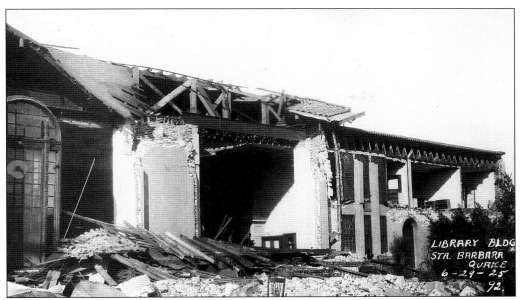

LIBRARY BUILDING, SANTA BARBARA QUAKE. (P/P: Unknown; date: June 1925.)

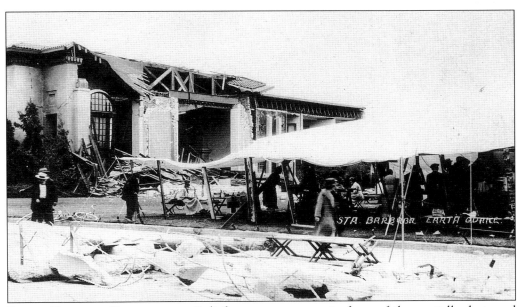

SANTA BARBARA EARTHQUAKE. Relief tents were set up in front of the partially destroyed Public Library building. (P/P: Unknown; date: June 1925.)

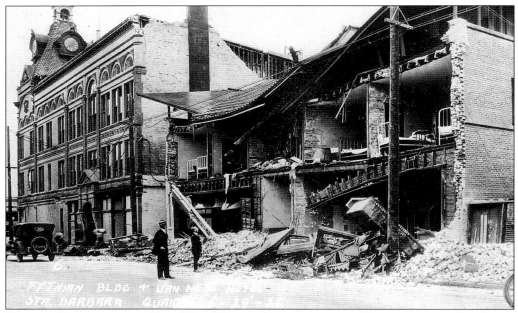

FYTHIAN BUILDING AND VAN NESS HOTEL, SANTA BARBARA QUAKE. "I immediately ran from my bedroom to the front lawn…As I stepped from the front porch to a slightly sloping grass plot, I was thrown violently…My wife and the gardener, who were on the opposite side of the house at the time, came through [the house]. In stepping from a tiled porch to the grass…both were thrown violently down…The roof was vibrating with sufficient force to break the tiles," said Hubert Nunn, Santa Barbara city manager, in the *Bulletin of the Seismological Society of America*, 15 (1925): 308-319. (P/P: Unknown; date: June 1925.)

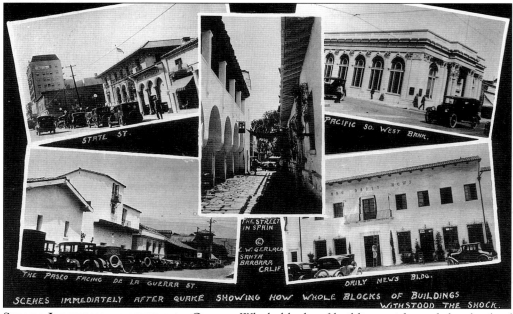

SCENES IMMEDIATELY AFTER THE QUAKE. Whole blocks of buildings withstood the shock of the quake. (P/P: Copyright G.W. Gerlock, Santa Barbara; date: June 1925.)

Four
Santa Barbara's Public Buildings and Spaces

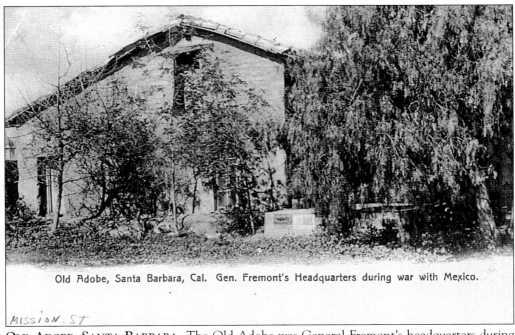

Old Adobe, Santa Barbara. The Old Adobe was General Fremont's headquarters during the war with Mexico. (P/P: M. Rieder, Los Angeles, No. 2205; printed in Germany.)

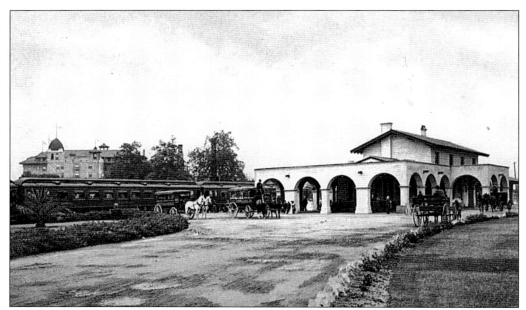

SOUTHERN PACIFIC RAILWAY STATION & SHORE LINE LIMITED, SANTA BARBARA. The railroad reached Santa Barbara from Los Angeles in 1887. (P/P: Detroit Publishing Co., No. 13374.)

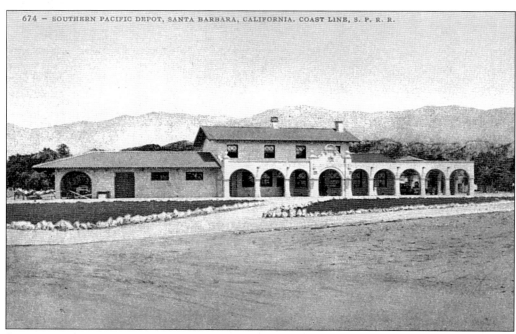

SOUTHERN PACIFIC DEPOT, SANTA BARBARA, COAST LINE S.P.R.R. The railroad was extended up the coast to San Francisco in 1901. (P/P: Edward H. Mitchell, San Francisco, No. 674.)

ENTRANCE TO INNER COURT, DE LA GUERRA STUDIOS, SANTA BARBARA. At one time, Santa Barbara was a film capital. (P/P: Osborne's, Santa Barbara.)

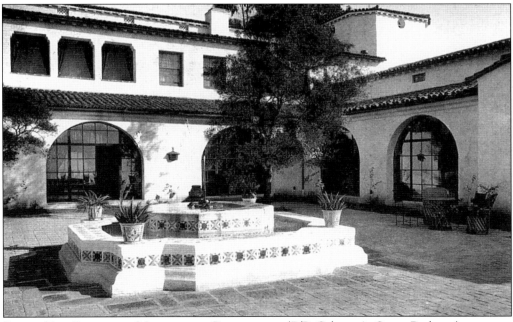

PATIO, THE BILTMORE, MONTECITO, CALIFORNIA. (P/P: Osborne's, Santa Barbara.)

"Street in Spain," Santa Barbara. Known as "El Paseo," this is a unique, Spanish-style shopping arcade. (P/P: Published for M.V. Carpenter.)

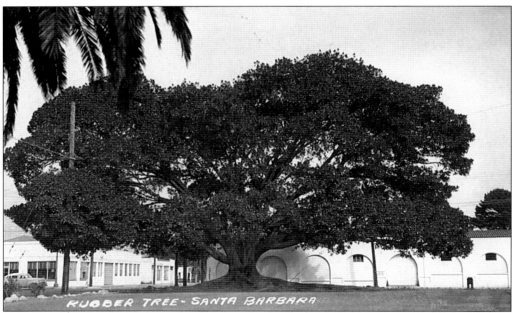

Rubber Tree, Santa Barbara. This Morton Bay Fig tree is a native of Australia. Originally planted in 1874, it was transplanted to its present location in 1877. It has a 160-foot span and provides 21,000 square feet of shade. (P/P: Unknown.)

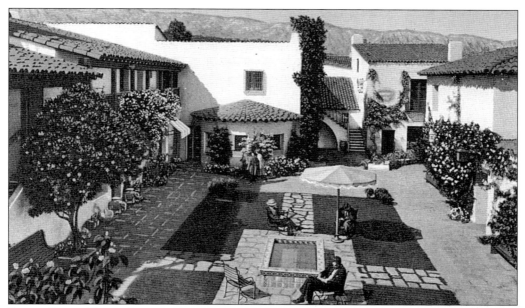

PATIO, PASEO DE LA GUERRA, SANTA BARBARA. "De la Guerra Studios and Shops are a group of buildings built around the original and historical De La Guerra home." (P/P: Western Publishing & Novelty Co., Los Angeles, No. SB 71.)

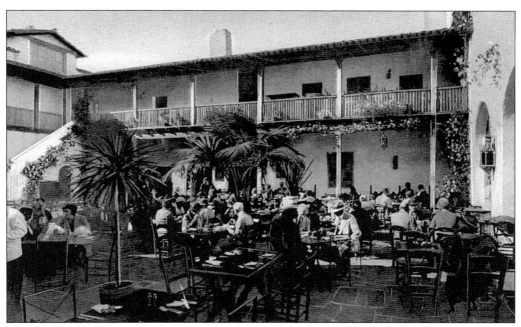

A PASEO TEA GARDEN, SANTA BARBARA. (P/P: Osborne's, Santa Barbara.)

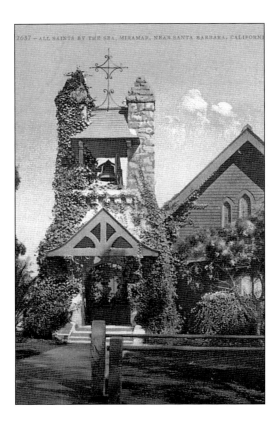

ALL SAINTS BY THE SEA, MIRAMAR, NEAR SANTA BARBARA. (P/P: Edward H. Mitchell, San Francisco, No. 2637.)

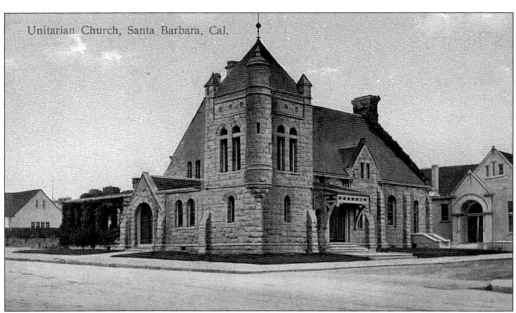

UNITARIAN CHURCH, SANTA BARBARA. (P/P: M. Rieder, Los Angeles, No. 4955; made in Germany.)

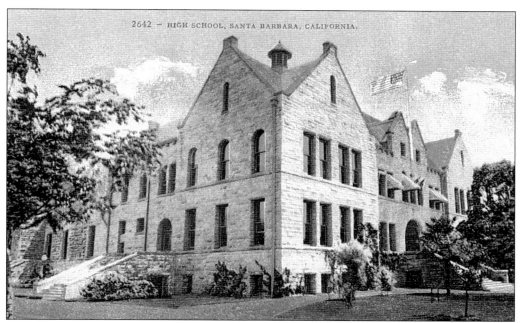

HIGH SCHOOL, SANTA BARBARA. (P/P: Edward H. Mitchell, San Francisco, No. 2642.)

WOMEN'S CLUB, SANTA BARBARA. (P/P: Osborne's, Santa Barbara.)

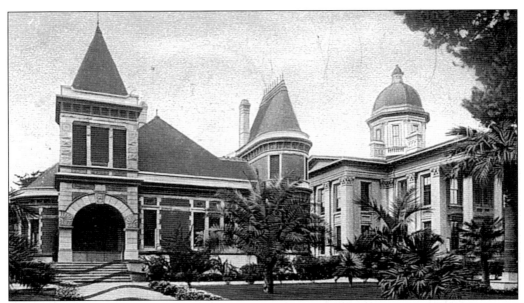

COURT HOUSE, SANTA BARBARA. (P/P: M. Rieder, Los Angeles, No. 282; made in Germany; undivided back; postmark: August 1905.)

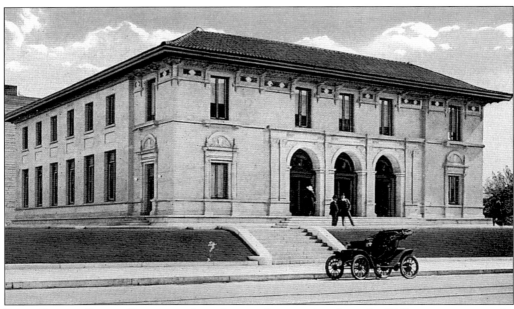

POST OFFICE, SANTA BARBARA. It took special permission from the U.S. government to be able to build this post office in "Santa Barbara" style instead of the usual box-like building. (P/P: Berkey & McGuire, Santa Barbara.)

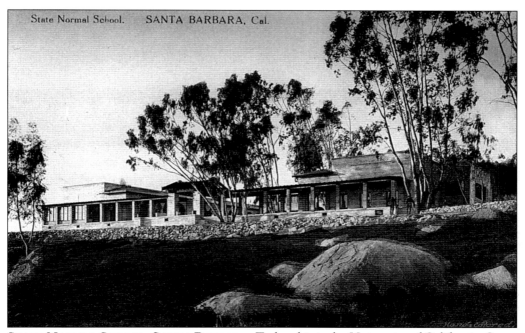

STATE NORMAL SCHOOL, SANTA BARBARA. Today this is the University of California, Santa Barbara. (P/P: Albertype, Brooklyn, NY.)

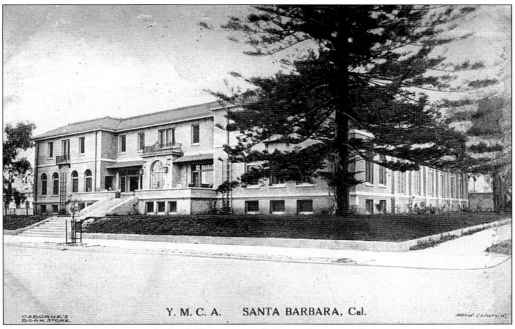

YMCA, SANTA BARBARA. (P/P: Osborne's Book Store, Santa Barbara; postmark: April 1917.)

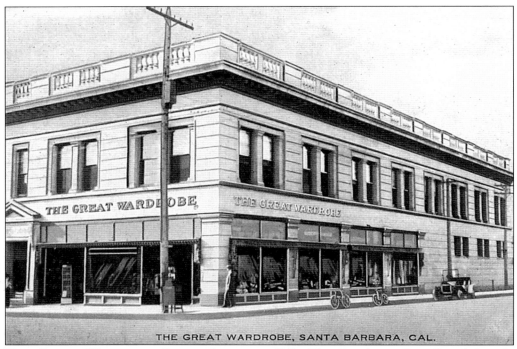

THE GREAT WARDROBE, SANTA BARBARA. (P/P: The Simplicity Co., Grand Rapids, Michigan.)

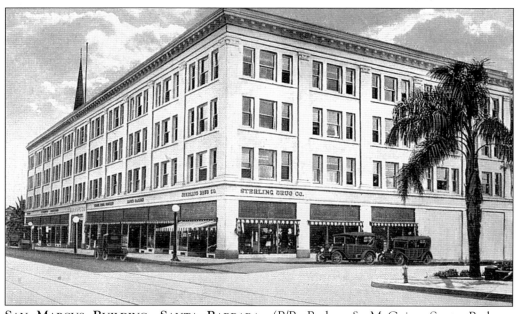

SAN MARCUS BUILDING, SANTA BARBARA. (P/P: Berkey & McGuire, Santa Barbara; No. A 57008.)

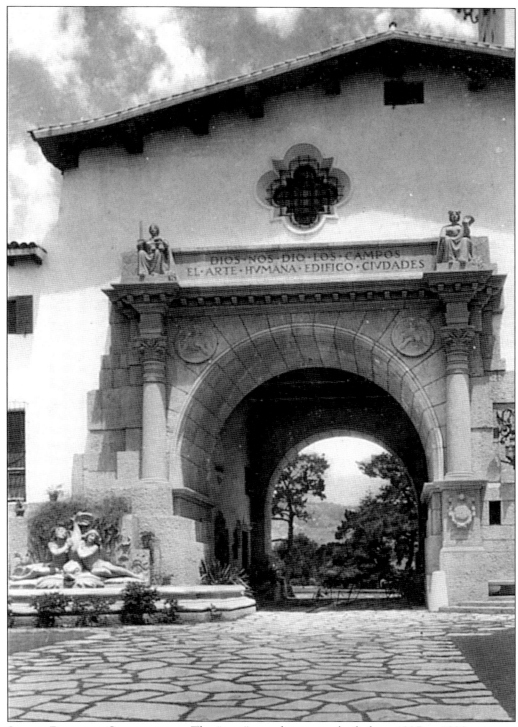

SANTA BARBARA COURTHOUSE. The "new" courthouse was built from 1927 to 1929 at a cost of $1,500,000. (P/P: Fred E.W. Martin, Pasadena, No. 1324.)

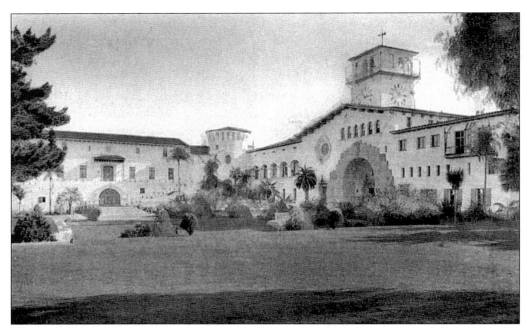

COUNTY COURTHOUSE, SANTA BARBARA. Surrounded by lawns and tropical gardens, this Spanish-Moorish building is an architectural gem. (P/P: Osborne's, Santa Barbara.)

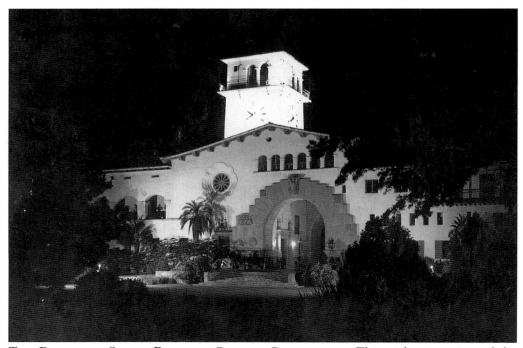

THE BEAUTIFUL SANTA BARBARA COUNTY COURTHOUSE. This night-time view of the courthouse was taken from the patio. (P/P: Frasher's Photo, Pomona, California, No. W 1335.)

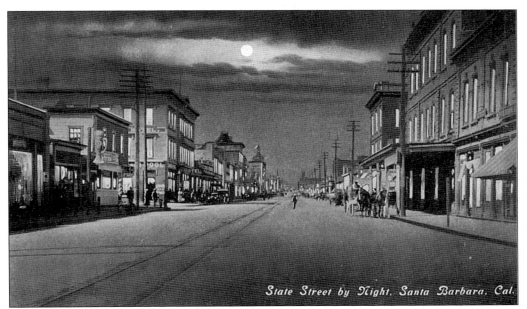

STATE STREET BY NIGHT, SANTA BARBARA. (P/P: Benham Co., Los Angeles, No. 3006.)

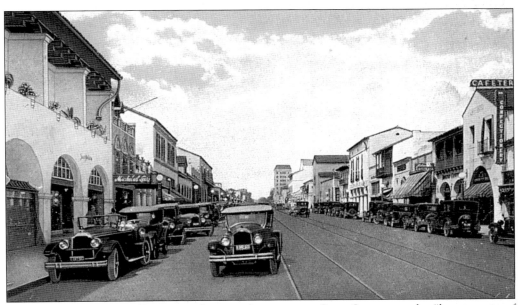

STATE STREET, SANTA BARBARA. In its early existence, State Street was the "largest strip of continuous paving on the coast." (P/P: Western Publishing & Novelty Co., Los Angeles, No. SB 88.)

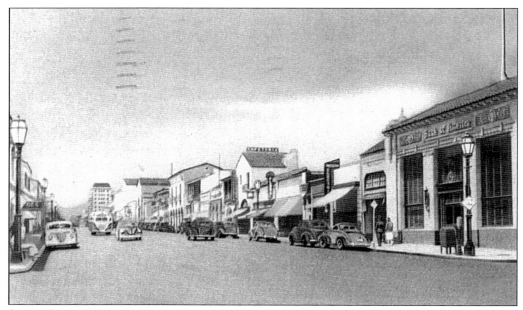

STATE STREET, SANTA BARBARA. A note on the back reads, "Sally and I have been in every store in this town. They have lots of merchandise but certainly don't know how to display it." (P/P: Robert Kashower. Los Angeles, No. SB 1; postmark: August 1942.)

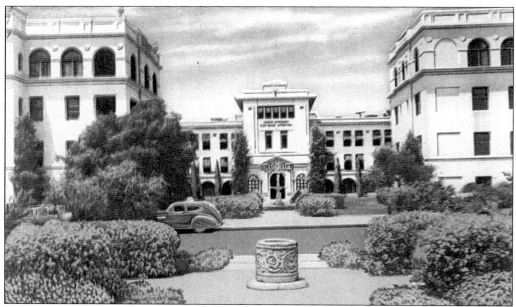

COTTAGE HOSPITAL, SANTA BARBARA. The text on the back of the card says, "Santa Barbara won a first award in a nation-wide health contest conducted by the U.S. Chamber of Commerce. Santa Barbara Cottage Hospital is one of the best equipped and staffed in the country." It was established in 1888. (P/P: Longshaw Card Co., Los Angeles, No. SB 6.)

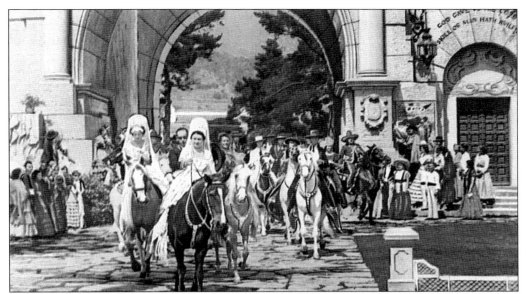

GAY FIESTA PARADE IN FRONT OF COURTHOUSE, SANTA BARBARA. (P/P: Theodore R. Ponto, Los Angeles, No. SB 11.)

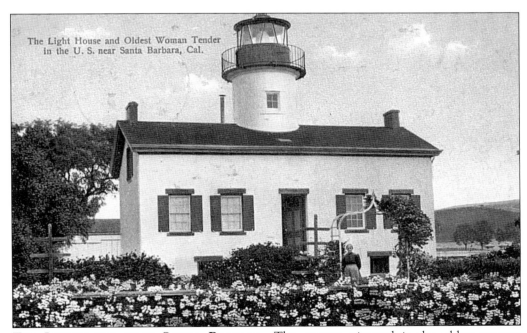

THE LIGHTHOUSE NEAR SANTA BARBARA. The woman pictured is the oldest woman lighthouse tender in the United States. (P/P: M. Rieder, Los Angeles, No. 3682; made in Germany; postmark: April 1908.)

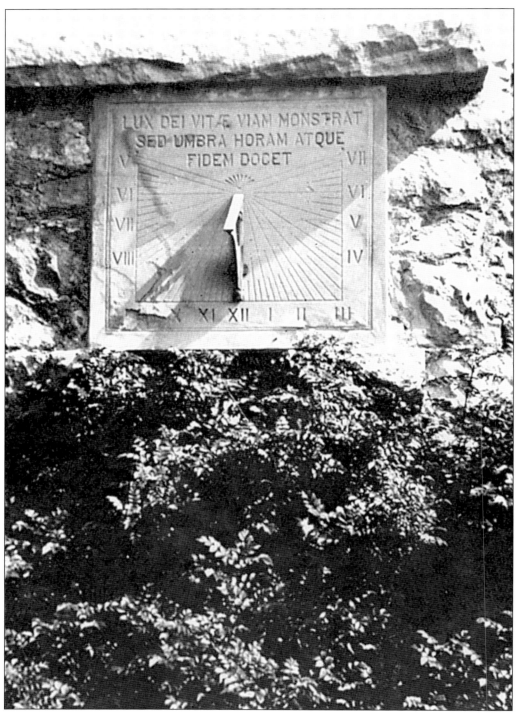

THE OLD SUN DIAL, ST. MARY'S RETREAT HOUSE, SANTA BARBARA. The translation of the inscription reads, "The Light of God shows the way of life but also teaches the faith in the darkness." (P/P: Unknown.)

Five
Santa Barbara Area Residences

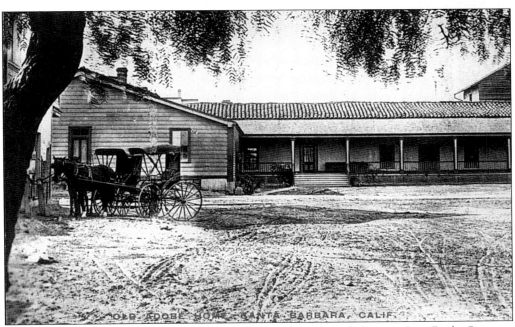

OLD ADOBE HOME, SANTA BARBARA. This residence was built by Don Jose De la Guerra y Noriega. The title, De la Guerra ("of the war"), was bestowed on him by Queen Isabella of Spain. (P/P: Artura.)

"El Cuartel," the Oldest House in Santa Barbara. This house is one of the original soldier houses erected by Captain Jose Francesco Ortega and Father Junipero Serra in April 1782. (P/P: Western Publishing & Novelty Co., Los Angeles, No. SB 103.)

El Paseo, De la Guerra Studios, Santa Barbara. (P/P: Osborne's, Santa Barbara.)

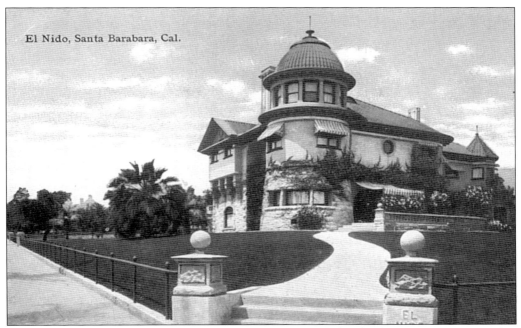

EL NIDO, AN EARLY SANTA BARBARA RESIDENCE. (P/P: Benham Co., Los Angeles, No. A 13900.)

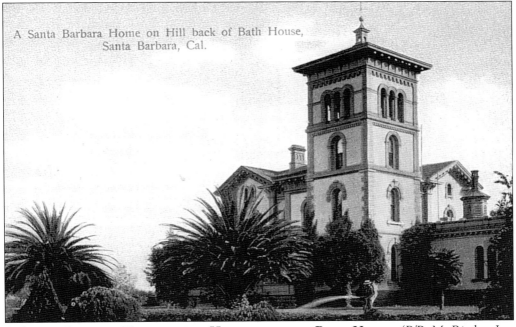

A SANTA BARBARA HOME ON THE HILL BEHIND THE BATH HOUSE. (P/P: M. Rieder, Los Angeles, No. 3812; made in Germany.)

CALIFORNIA BUNGALOWS ON MOTOR DRIVE FROM THE POTTER HOTEL. (P/P: Detroit Publishing Co. No. 70427; postmark: August 1912.)

HOME OF STEWART EDWARD WHITE, SANTA BARBARA. (P/P: Western Publishing & Novelty Co., Los Angeles, No. SB 68.)

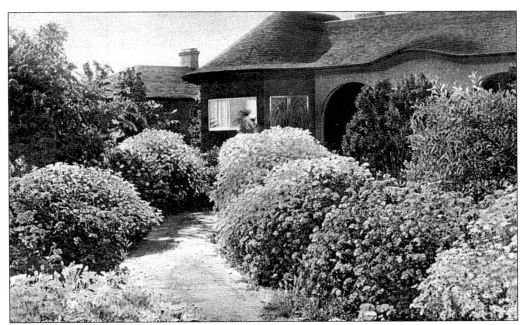

SCENE AT MIRAMAR NEAR SANTA BARBARA. (P/P: M. Rieder, Los Angeles, No. 3680; made in Germany.)

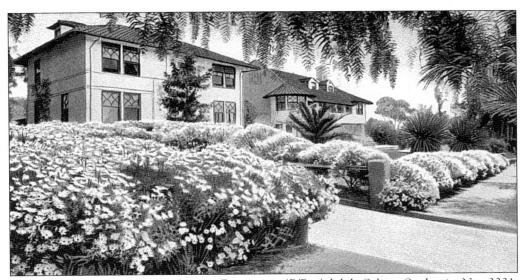

HOME AMONG THE DAISIES, SANTA BARBARA. (P/P: Adolph Selige, St. Louis, No. 3331; undivided back.)

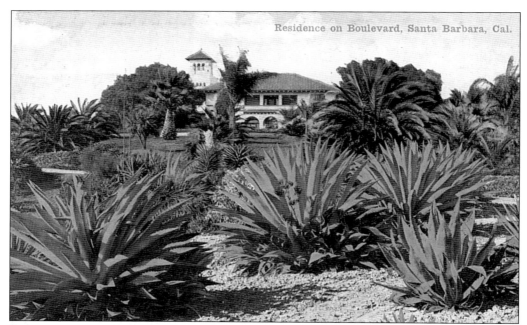

Residence on the Boulevard, Santa Barbara. (P/P: Souvenir Publishing Co., Los Angeles and San Francisco, No. M 21; rubber stamped: W.K. Franklin Musical Merchandise, Lordsburg, Cal.)

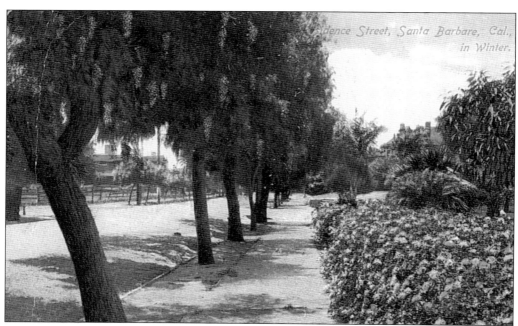

Residence Street, Santa Barbara, in Winter. (P/P: M. Rieder, Los Angeles, No. 31871; made in Germany; postmark: September 1908.)

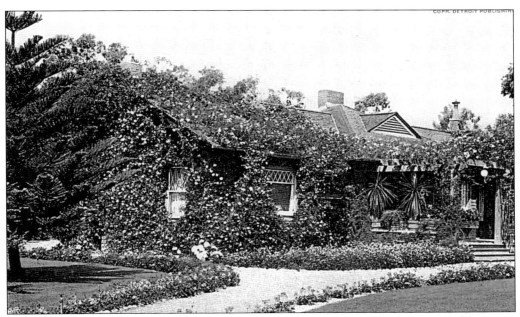

A ROSE EMBOWERED BUNGALOW ON MOTOR DRIVE FROM THE POTTER HOTEL. (P/P: Detroit Publishing Co., No. 13385.)

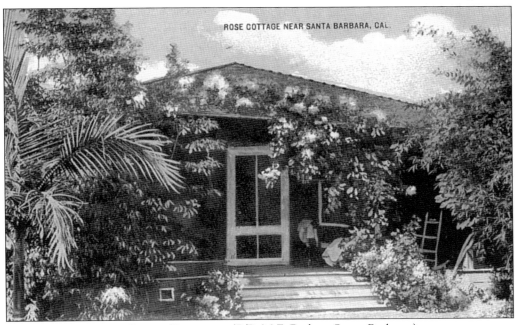

ROSE COTTAGE NEAR SANTA BARBARA. (P/P: M.F. Berkey, Santa Barbara.)

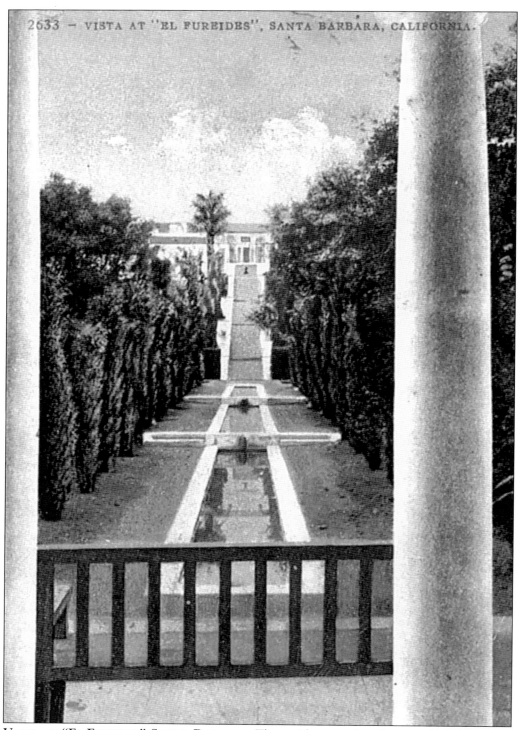

VISTA AT "EL FUREIDES" SANTA BARBARA. This residence and gardens was built by Joseph Waldron Gillespie in Montecito. (P/P: Edward H. Mitchell, San Francisco, No. 2633.)

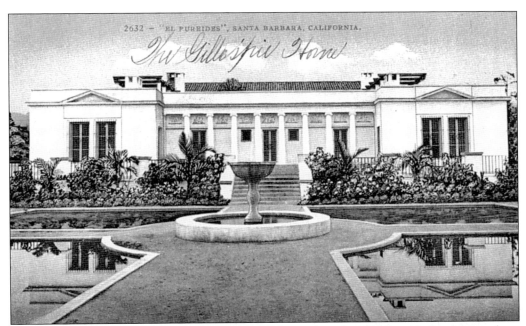

"EL FUREIDES" SANTA BARBARA. In May 1914, *Sunset* described "El Fureides" as "thirty-three acres divided between gardens and a woods…Quiet ponds play an important part of the decorative scheme of the gardens." (P/P: Edward H. Mitchell, San Francisco, No. 12632.)

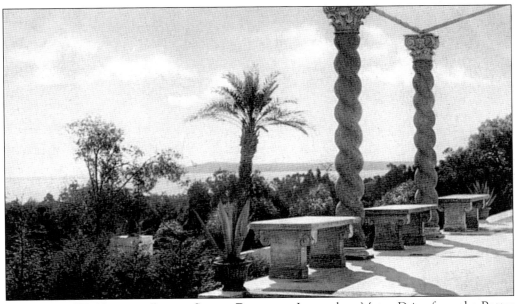

VIEW FROM "EL FUREIDES" NEAR SANTA BARBARA. Located on Motor Drive from the Potter Hotel, the gardens were European and Persian inspired and had over 125 varieties of palm trees. (P/P: Detroit Publishing Co., No. 13183.)

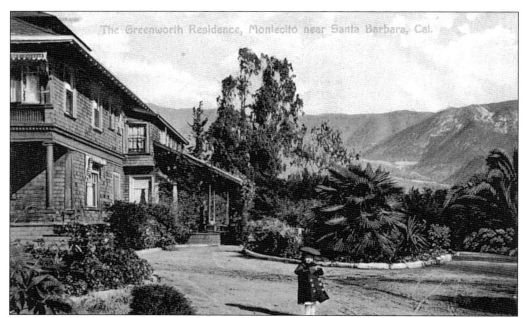

The Greenworth Residence, Montecito, near Santa Barbara. (P/P: Newman Post Card Co., Los Angeles, No. 5633; made in Germany; postmark: November 1907.)

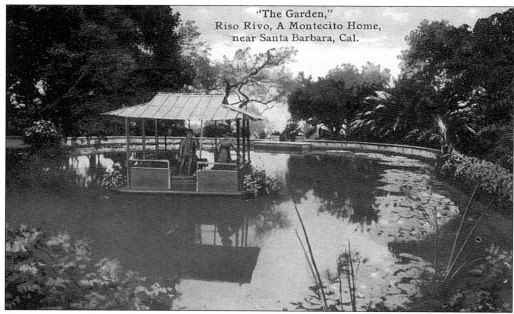

"The Garden" Riso Rivo, a Montecito Home, near Santa Barbara. (P/P: Benham Co., Los Angeles, No. 3012; postmark: April 1914.)

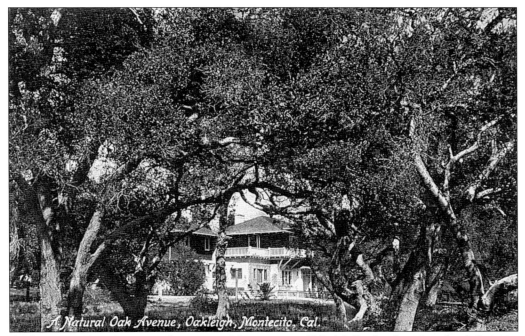

A Natural Oak Avenue, Oakleigh, Montecito. (P/P: M. Rieder, Los Angeles & Leipzig, No. 3679; made in Germany.)

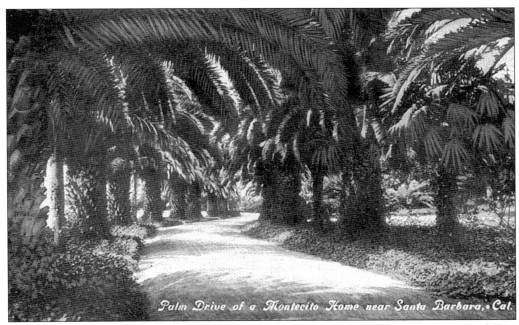

Palm Drive of a Montecito Home, near Santa Barbara. (P/P: Carlin Post Card Co., Los Angeles, No. A 13899.)

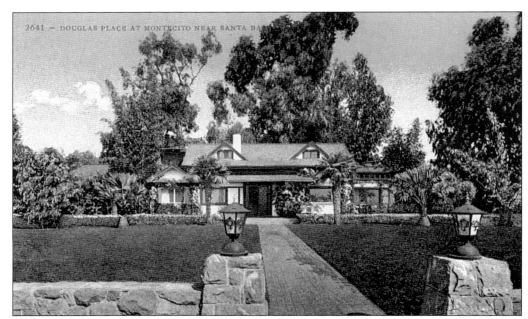

THE JAMES S. DOUGLAS ESTATE AT MONTECITO. This estate eventually became the site of the Biltmore Hotel. (P/P: Edward H. Mitchell, San Francisco, No. 2641.)

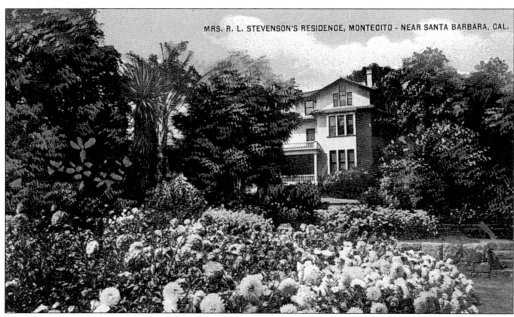

MRS. R[OBERT] L[OUIS] STEVENSON'S RESIDENCE, MONTECITO, NEAR SANTA BARBARA. (P/P: M.F. Berkey, Santa Barbara; postmark: May, 1916.)

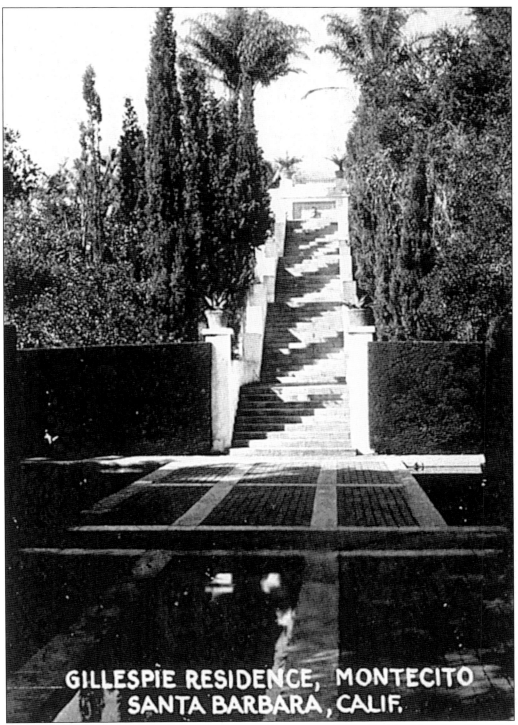

Gillespie Residence, Montecito, Santa Barbara. (P/P: Pacific Novelty Co., San Francisco.)

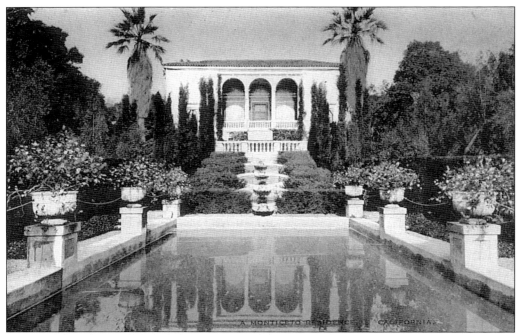

A Montecito Residence, with its Gardens and Pool. (P/P: Osborne's, Santa Barbara.)

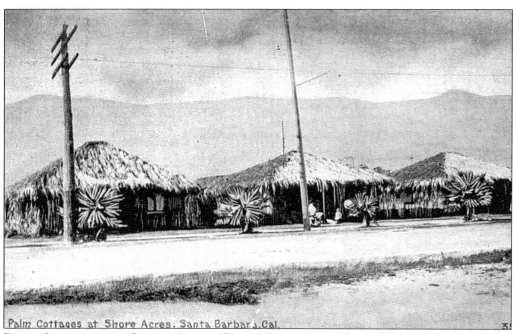

Palm Cottages at Shore Acres, Santa Barbara. (P/P: California Sales Co., San Francisco; No. 392.)

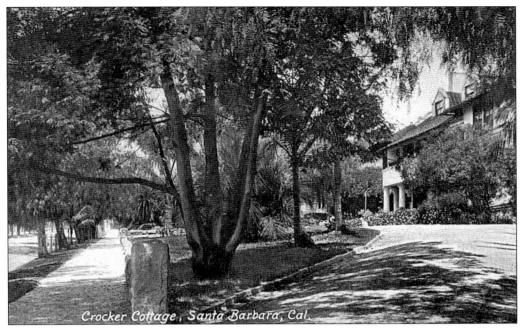

CROCKER COTTAGE, SANTA BARBARA. Charles Crocker built five large cottages, which were set back from the street to provide ocean views. (P/P: M. Rieder, Los Angeles, No. 3810; made in Germany.)

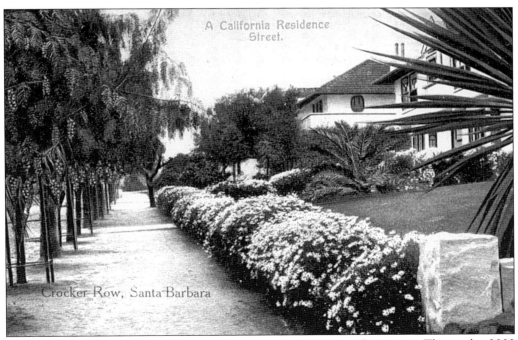

A CALIFORNIA RESIDENTIAL STREET, CROCKER ROW, SANTA BARBARA. This is the 2000 block of Garden. (P/P: Newman Post Card Co., Los Angeles; made in Germany.)

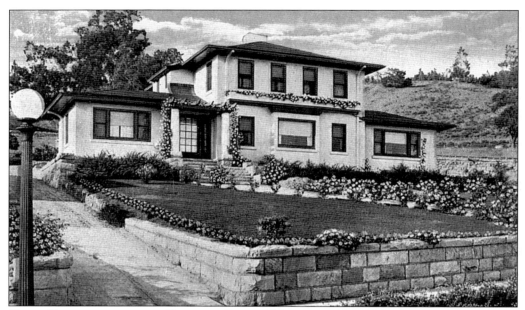

GAUD RESIDENCE, ON THE RIVIERA, SANTA BARBARA. "Unsurpassed view of city, ocean, mountains, islands and valleys, 350 to 550 feet above sea level…" wrote one observer. (P/P: M.F. Berkey, Santa Barbara, No. A 66765.)

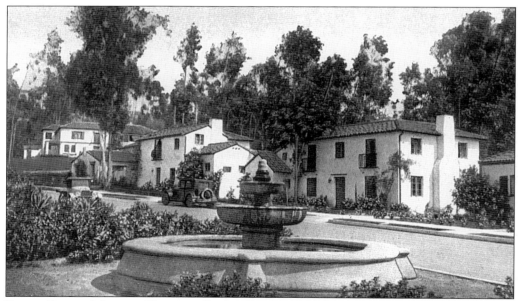

RUBIO PLAZA, MISSION HEIGHTS, SANTA BARBARA. (P/P: Western Publishing & Novelty Co., Los Angeles, No. 5696.)

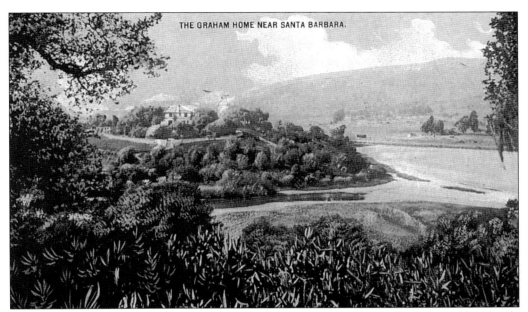

THE GRAHAM HOME, NEAR SANTA BARBARA. Modern dancer Martha Graham and her family moved here in 1908. This picture was taken about 1915. (P/P: M.F. Berkey, Santa Barbara.)

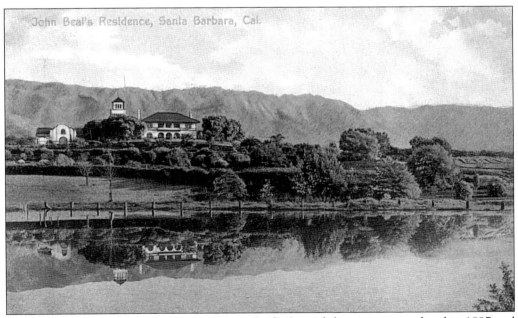

JOHN BEAL'S RESIDENCE, SANTA BARBARA. Beal's Spanish house was completed in 1897 and named Vegamar. The property is now the site of the bird sanctuary. (P/P: Newman Post Card Co., Los Angeles; made in Germany.)

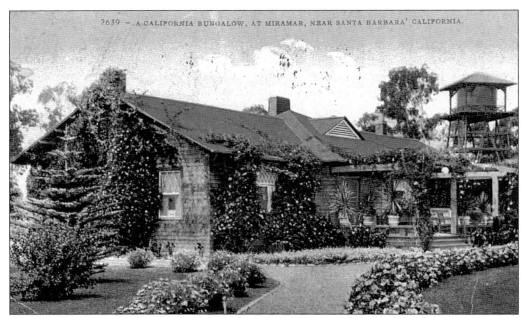

A California Bungalow at Miramar, near Santa Barbara. (P/P: Edward H. Mitchell, San Francisco, No. 2639; postmark: December 1910.)

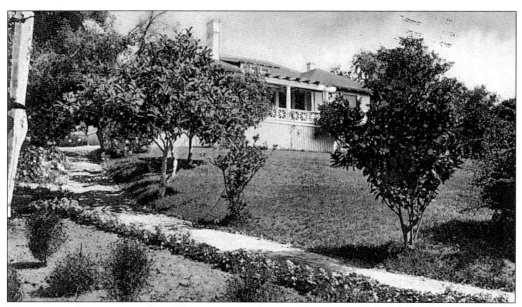

Magnolia Cottage at San Ysidro, near Santa Barbara. (P/P: M. Rieder, Los Angeles & Dresden, No. 2863; undivided back; postmark: April 1906.)

Six
Santa Barbara Beaches and Views

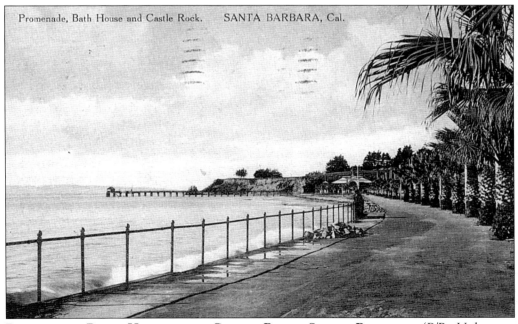

PROMENADE, BATH HOUSE, AND CASTLE ROCK, SANTA BARBARA. (P/P: Unknown; postmark: September 1922.)

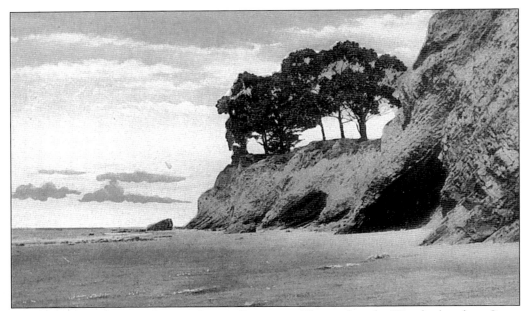

SECOND POINT, NORTH BEACH, SANTA BARBARA. The card reads, "On the beach at Santa Barbara, California. Noted for its balmy climate, the mecca of all who would escape the chill of winter. 350 days of sunshine. Bathing all the year." (P/P: M.F. Berkey, Santa Barbara, No. R 76940.)

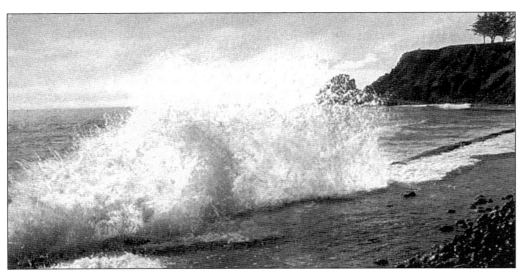

"WHERE WE SIT WATCHING THE WAVES BREAK," CASTLE ROCK, SANTA BARBARA. (P/P: M. Rieder, Los Angeles, No. 3032; made in Germany.)

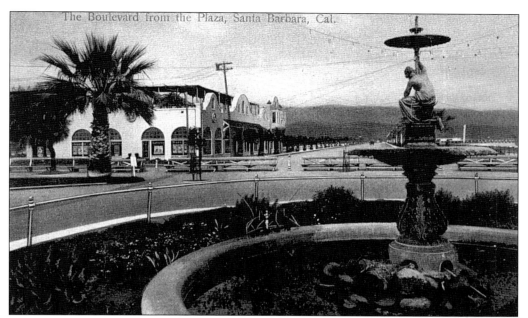

VIEW OF THE BOULEVARD FROM THE PLAZA, SANTA BARBARA. "The ideal climate of Santa Barbara is proverbial the world over...only 12 degrees of difference between the mean temperature of July and January." (P/P: M. Rieder, Los Angeles, No. 5272; made in Germany; postmark: July 1919.)

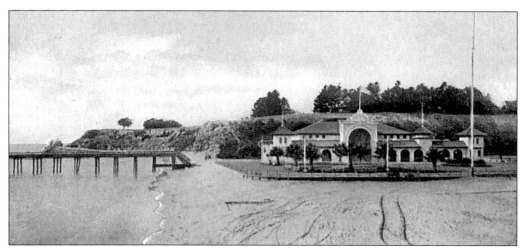

BATH HOUSE AND CASTLE ROCK, SANTA BARBARA. (P/P: M. Rieder, Los Angeles, No. 585; undivided back.)

CASTLE ROCK, SANTA BARBARA. (P/P: Unknown; undivided back; postmark: May 1907.)

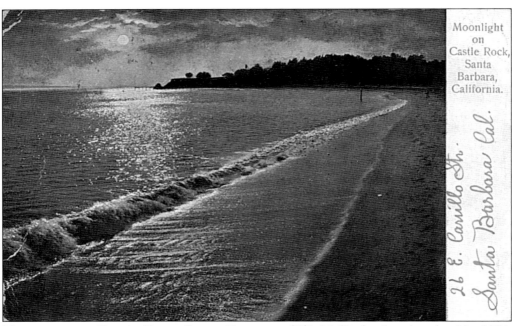

MOONLIGHT ON CASTLE ROCK, SANTA BARBARA. (P/P: M. Rieder, Los Angeles, No. 3034; made in Germany.)

BEACH SCENE, IN THE HOPE RANCH, SANTA BARBARA. (P/P: Brock Higgins Photo.)

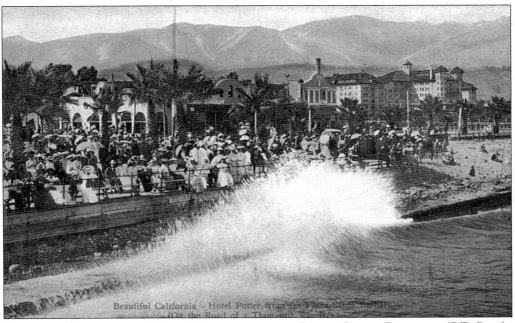

BEAUTIFUL CALIFORNIA—HOTEL POTTER FROM THE PLAZA, SANTA BARBARA. (P/P: Pacific Novelty Co., San Francisco, No. 62870; made in Germany; postmark: 1908.)

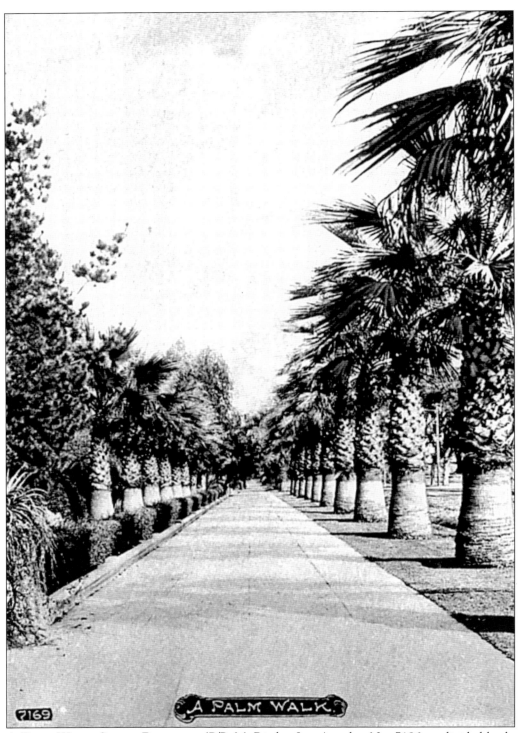

A Palm Walk, Santa Barbara. (P/P: M. Rieder, Los Angeles, No. 7196; undivided back; postmark: June 1906.)

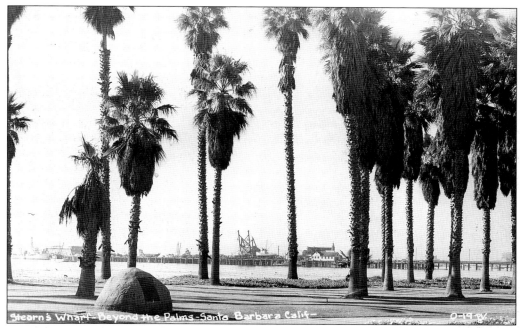

STEARNS'S WHARF—BEYOND THE PALMS, SANTA BARBARA. Built by John Peck Stearns in 1872, Stearns's Wharf is the oldest working pier on the west coast. (P/P: Unknown, No. 019PV.)

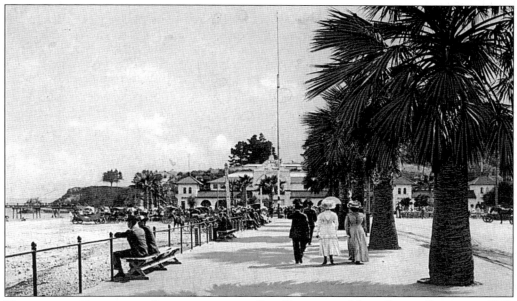

VIEW OF THE BOULEVARD LOOKING TOWARD LOS BANOS DEL MAR, SANTA BARBARA. (P/P: Detroit Publishing Co., No. 13373.)

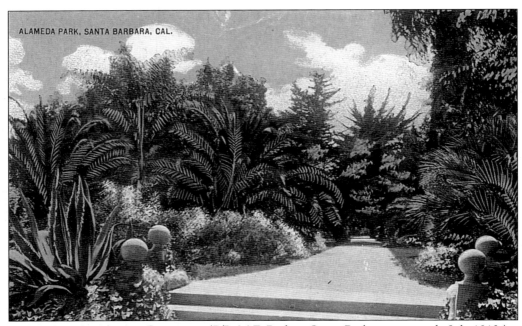
ALAMEDA PARK, SANTA BARBARA. (P/P: M.F. Berkey, Santa Barbara; postmark: July 1913.)

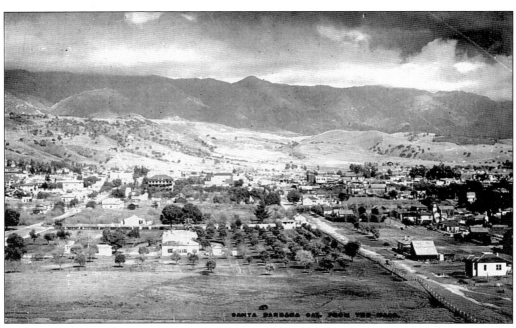
A VIEW OF SANTA BARBARA FROM THE MESA. (P/P: N.H. Reed, Santa Barbara.)

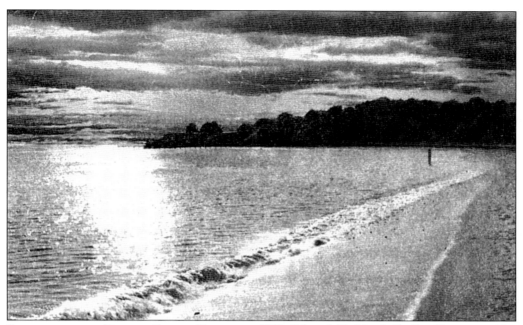

SUNSET ON THE BEACH, SANTA BARBARA. (P/P: Edward H. Mitchell, San Francisco, No. 10002; postmark: October 1910.)

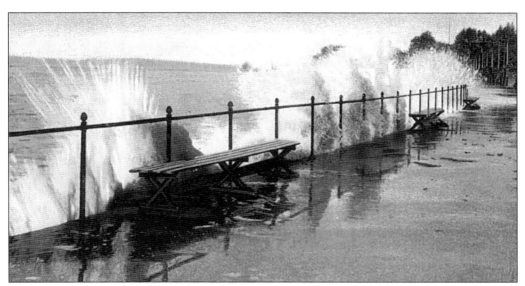

WHERE THE WAVES BREAK AT HIGH TIDE, SANTA BARBARA. (P/P: Adolph Selige, St. Louis; undivided back; copyright N.H. Reed, 1899.)

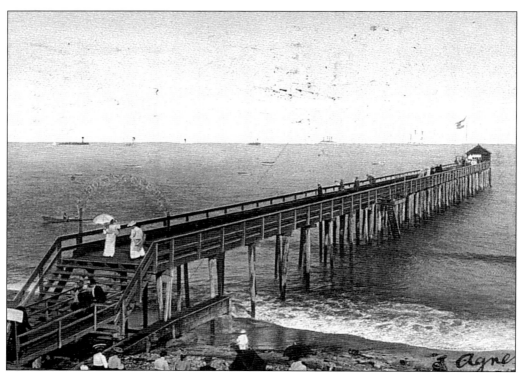

PIER AT SANTA BARBARA. Built at the foot of State Street in 1872, Stearns's Wharf was restored in 1981. (P/P: M. Rieder, Los Angeles & Leipzig, No. 3262; postmark: February 1909.)

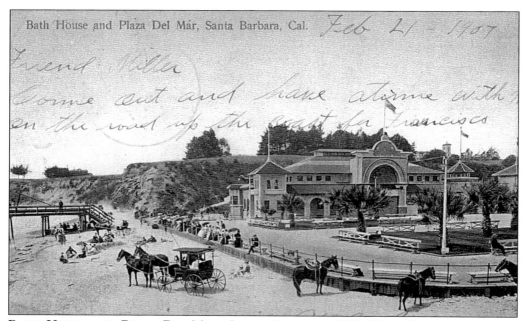

BATH HOUSE AND PLAZA DEL MAR, SANTA BARBARA. (P/P: M. Rieder, Los Angeles & Leipzig, No. 3177, postmark: February 1907.)

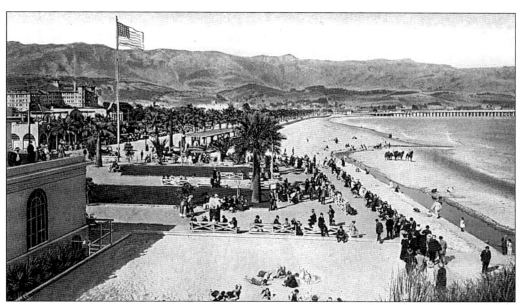

ON THE BEACH AT BEAUTIFUL SANTA BARBARA. This card reads, "The Mecca of all who would escape the chill of winter." (P/P: M.F. Berkey, Santa Barbara, No. A 66752.)

BIG WAVES AT SANTA BARBARA. (P/P: Pacific Novelty Co., San Francisco & Los Angeles, No. L 32.)

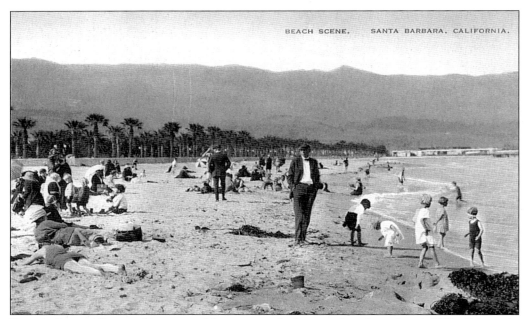

BEACH SCENE, SANTA BARBARA. Not too much danger of sunburn here! (P/P: Osborne's, Santa Barbara.)

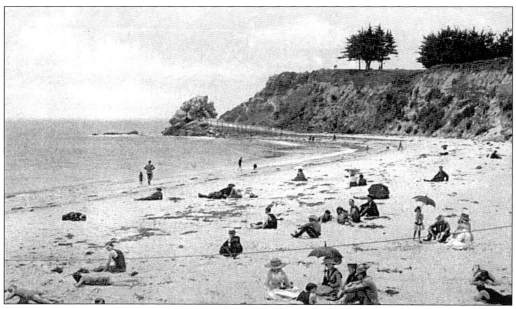

CASTLE ROCK AND BATHING BEACH, SANTA BARBARA. (P/P: Detroit Publishing Co., No 13377; postmark: August 1916.)

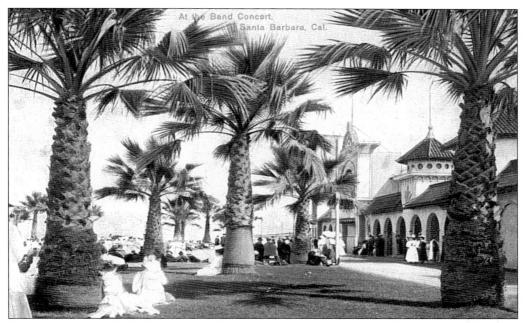

AT THE BAND CONCERT, SANTA BARBARA. (P/P: Newman Post Card Co., Los Angeles, No. M 9.)

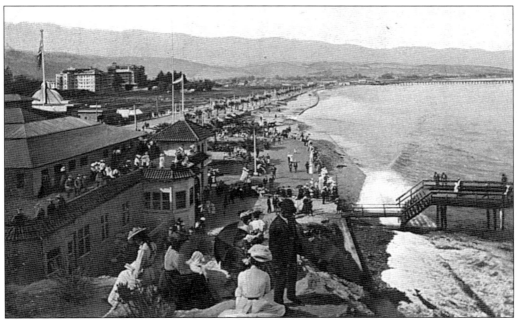

A SUNDAY ON THE BLUFF, SANTA BARBARA. (P/P: M. Rieder, Los Angeles, No. 304 [?]; made in Germany; undivided back.)

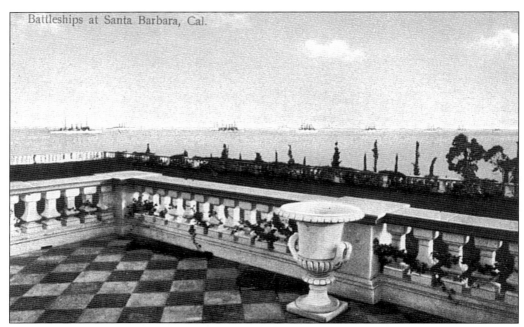

BATTLESHIPS AT SANTA BARBARA. "The smooth waters of the Santa Barbara Channel, protected by the four Channel Islands, make Santa Barbara a favorite stopping place for the battle-ships." (P/P: M. Rieder, Los Angeles, No. 5287; made in Germany.)

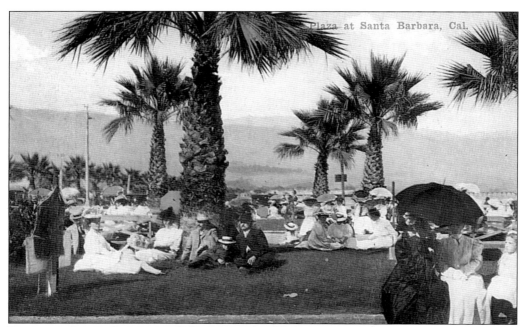

PLAZA AT SANTA BARBARA. (P/P: Souvenir Publishing Co., Los Angeles & San Francisco, No. M 16.)

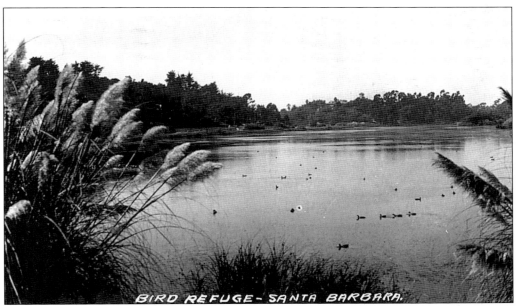

BIRD REFUGE, SANTA BARBARA. (P/P: Unknown; postmark: October 1946.)

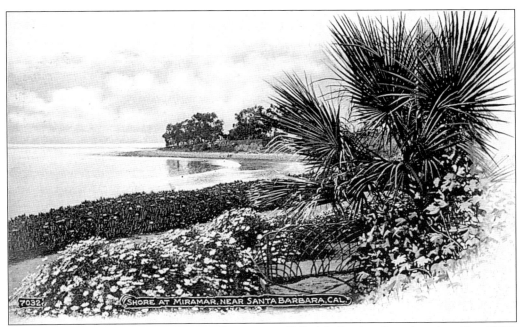

SHORE AT MIRAMAR, NEAR SANTA BARBARA. (P/P: M. Rieder, Los Angeles, No. 7032; undivided back.)

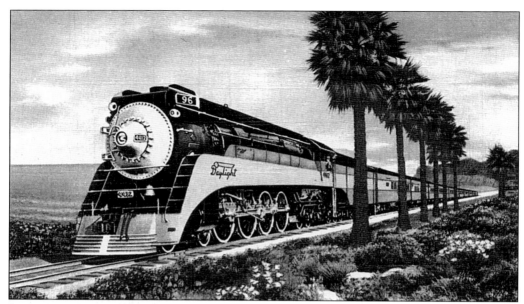

SOUTHERN PACIFIC "DAYLIGHT" COAST LINE, LOS ANGELES TO SAN FRANCISCO. "No rail trip anywhere, unfolds more thrilling scenery—following the very edge of the Pacific Ocean for more than a hundred miles." (P/P: Western Publishing & Novelty Co., Los Angeles, No. 507.)

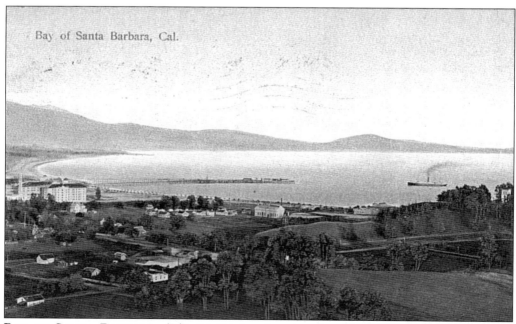

BAY OF SANTA BARBARA. (P/P: M. Rieder, Los Angeles, No. 3175; made in Germany; postmark: July 1910.)

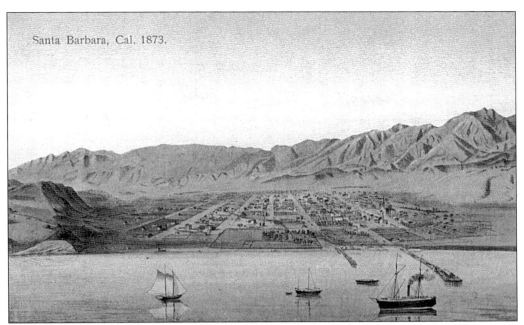

SANTA BARBARA, 1873. (P/P: M. Rieder, Los Angeles & Leipzig, No. 3625; made in Germany.)

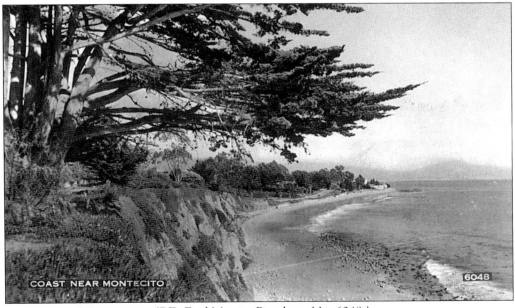

COAST NEAR MONTECITO. (P/P: Fred Martin, Pasadena, No. 6048.)

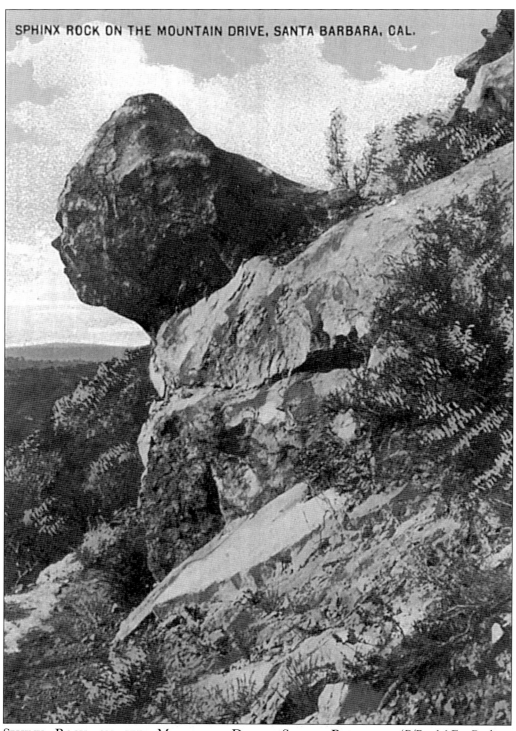

Sphinx Rock on the Mountain Drive, Santa Barbara. (P/P: M.F. Berkey, Santa Barbara.)

Seven
Santa Barbara County Places and Sights

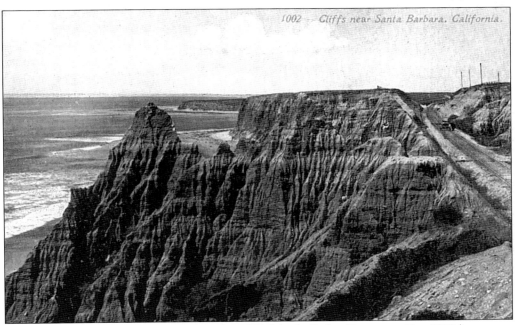

CLIFFS NEAR SANTA BARBARA. (P/P: Edward H. Mitchell, San Francisco, No. 1002.)

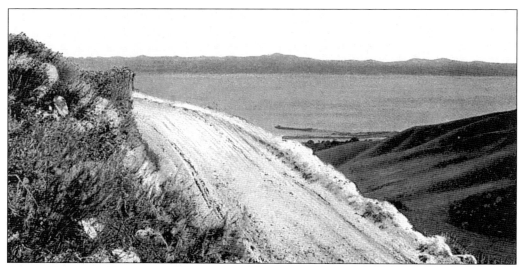

Santa Barbara Bay, with Views from Mountain Drive. (P/P: Adolph Selige Co., St. Louis, No. 3343; undivided back.)

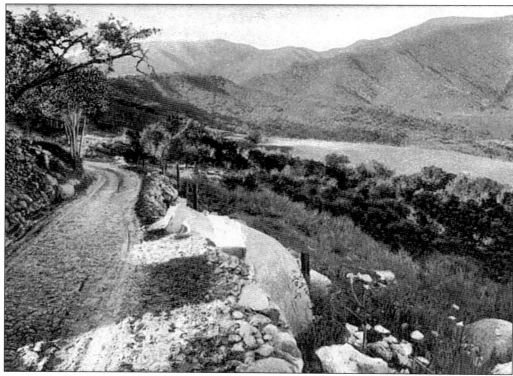

Observation Point, Mountain Drive, Santa Barbara. (P/P: Adolph Selige Co., St. Louis, No. 3349; undivided back.)

SYCAMORE CANON, MOUNTAIN DRIVE, SANTA BARBARA. (P/P: Adolph Selige Co., St. Louis, No. 3351; undivided back.)

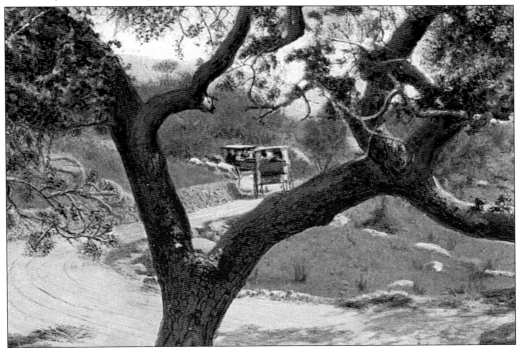

THE "Y" TREE ON MOUNTAIN DRIVE, SANTA BARBARA. (P/P: Adolph Selige Co., St. Louis, No. 3344; undivided back.)

THE LONE OAK ON MOUNTAIN DRIVE, SANTA BARBARA. (P/P: Adolph Selige Co., St. Louis, No. 3345; undivided back.)

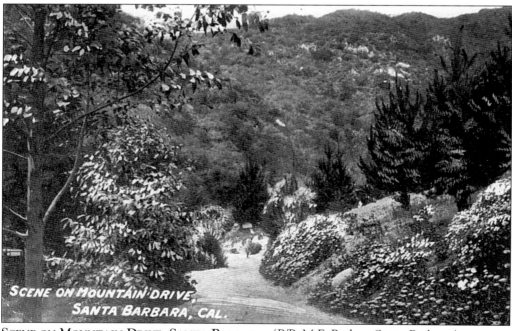

SCENE ON MOUNTAIN DRIVE, SANTA BARBARA. (P/P: M.F. Berkey, Santa Barbara.)

WINTER IN OAK PARK, SANTA BARBARA. (P/P: Benham, Los Angeles, No. A 13929.)

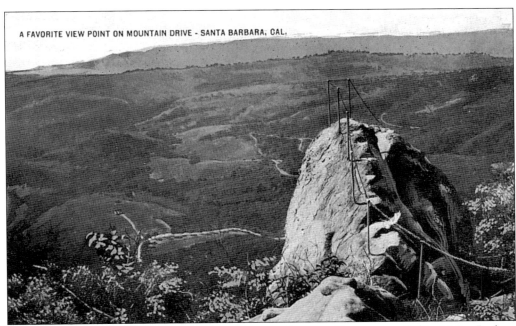

A FAVORITE VIEW ON MOUNTAIN DRIVE, SANTA BARBARA. (P/P: M.F. Berkey, Santa Barbara.)

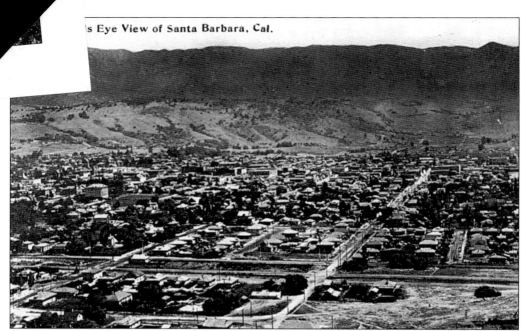

BIRD'S-EYE VIEW OF SANTA BARBARA. (P/P: Western Publishing & Novelty Co., Los Angeles, No. 456.)

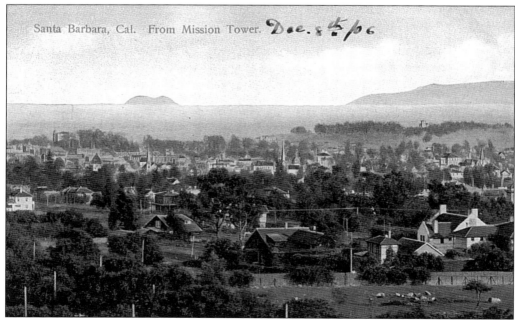

SANTA BARBARA, FROM MISSION TOWER. (P/P: M. Rieder, Los Angeles & Leipzig, No. 3173; handwritten date: December 8, 1906.)

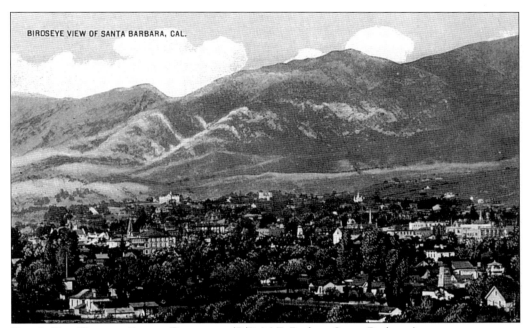

BIRD'S-EYE VIEW OF SANTA BARBARA. (P/P: M.F. Berkey, Santa Barbara.)

BIRD'S-EYE VIEW OF SANTA BARBARA FROM THE RIVIERA. (P/P: Western Publishing & Novelty Co., Los Angeles, No. SB 108; photo by Ricks.)

VIEW OF HOPE RANCH FROM THE RESERVOIR, SANTA BARBARA. This has been called "one of the beautiful drives to be enjoyed at Santa Barbara." (P/P: M. Rieder, Los Angeles, No. 4463; made in Germany.)

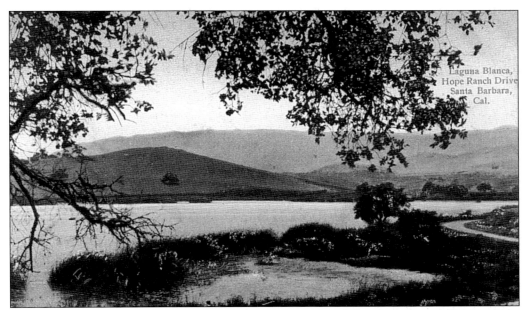

LAGUNA BLANCA, HOPE RANCH DRIVE, SANTA BARBARA. "This fresh water lake is nearly a mile and a half in circumference, and is used for storage of surplus water. During the Winter season, the lake is the retreat of thousands of wild ducks and geese. . . " (P/P: M. Rieder, Los Angeles, No. 5283; made in Germany.)

A DRIVE THROUGH THE OAKS, HOPE RANCH, ON MOTOR DRIVE FROM THE POTTER HOTEL. (P/P: Detroit Publishing Co., No. 13376.)

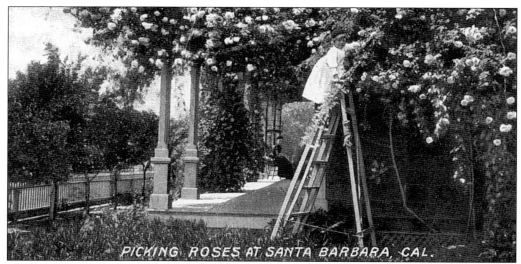

PICKING ROSES AT SANTA BARBARA. (P/P: Adolph Selige Publishing Co., St. Louis, Leipzig, Berlin, No. 3333; undivided back; printed in Germany; postmark: May 1907.)

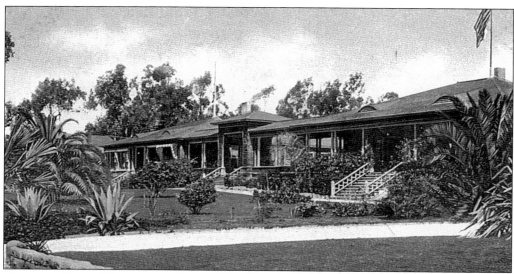

COUNTRY CLUB, MONTECITO, SANTA BARBARA. The club had a nine-hole golf course. (P/P: M. Rieder, Los Angeles & Leipzig, No. 3176; handwritten date: December 8, 1906.)

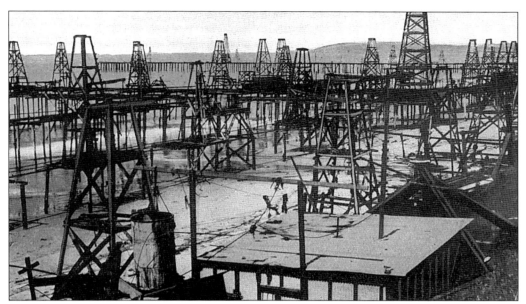

OIL WELLS IN THE SEA, SUMMERLAND, NEAR SANTA BARBARA. "Seaside gasoline is made here." (P/P: Western Publishing & Novelty, Los Angeles; No. SB 61.)

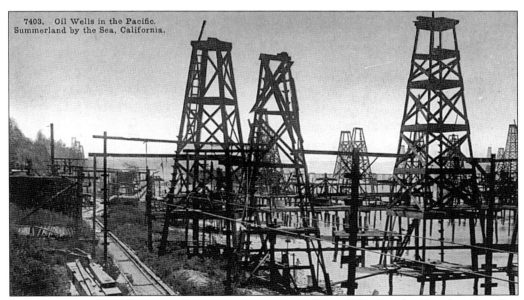

OIL WELLS IN THE PACIFIC, SUMMERLAND BY THE SEA. (P/P: Pacific Novelty Co., San Francisco, No. 7403.)

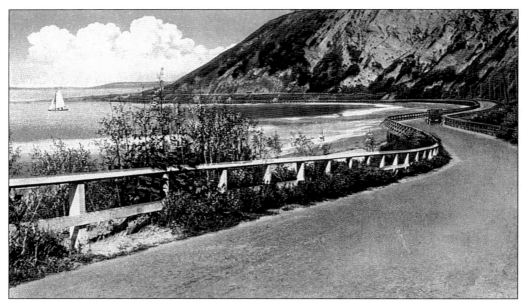

ON THE COAST HIGHWAY NEAR SANTA BARBARA. "An enjoyable trip for the autoist is the four hour run from Los Angeles to Santa Barbara on this scenic boulevard." (P/P: M.F. Berkey, Santa Barbara, No. A 74556.)

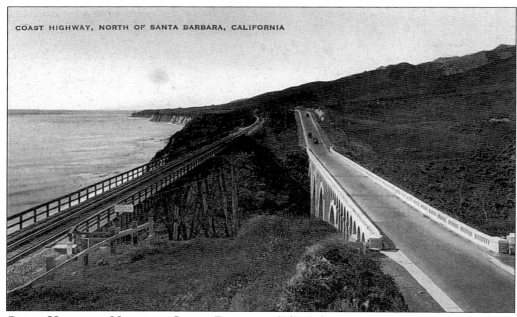

COAST HIGHWAY, NORTH OF SANTA BARBARA. (P/P: Osborne's, Santa Barbara.)

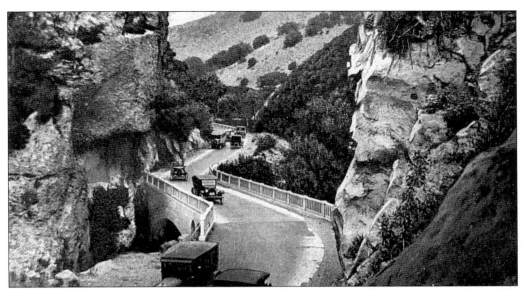

LOS CRUCES CREEK, ENTRANCE TO GAVIATA [sic] PASS, NEAR SANTA BARBARA. (P/P: Western Publishing & Novelty Co., Los Angeles.)

LOS CRUCES CREEK, GAVIOTA PASS NEAR SANTA BARBARA. "On the Coast Highway…In motoring north, after miles of beautiful ocean scenery it is here that the highway leaves the coast and winds its way through the Santa Barbara mountains with their unsurpassed beauty." (P/P: M.F. Berkey, Santa Barbara, No. R 76941.)

View of Santa Barbara from the Hill in back of the Bath House. (P/P: M. Rieder, Los Angeles; made in Germany; undivided back.)

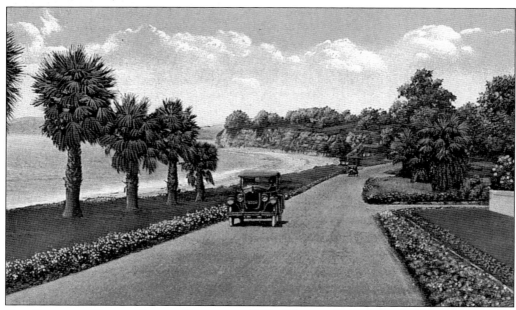

On Channel Drive, Santa Barbara. (P/P: Western Publishing & Novelty Co., Los Angeles, No. SB 84.)

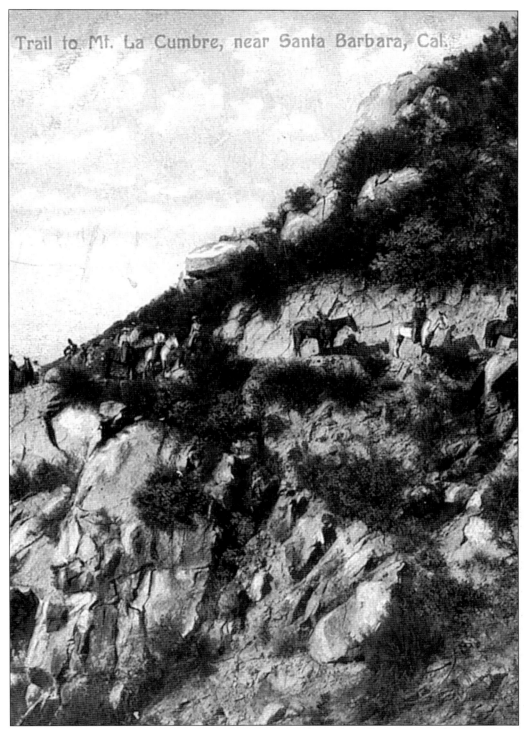

TRAIL TO MT. LA CUMBRE, NEAR SANTA BARBARA. This is the tallest point in the Santa Ynez mountains. (P/P: Newman Post Card Co., Los Angeles; made in Germany.)

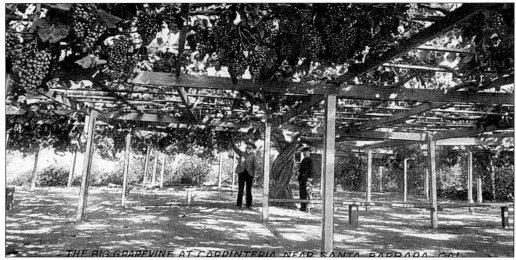

THE GRAPEVINE AT CARPINTERIA, NEAR SANTA BARBARA. This grapevine was thought to have been planted in 1846. Two feet above the ground, it measured 9 feet 4 inches in circumference, and its branches covered one quarter acre. The vine died in about 1914. (P/P: Adolph Selige Co., St. Louis; printed in Germany; undivided back; postmark: December 1908.)

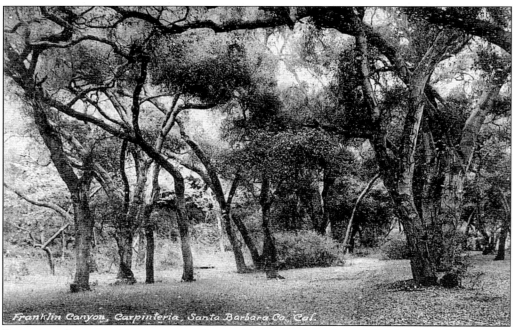

FRANKLIN CANYON, CARPINTERIA, SANTA BARBARA CO., CAL. (P/P: Unknown.)

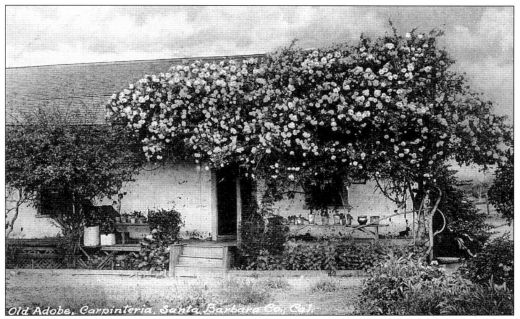

OLD ADOBE, CARPINTERIA, SANTA BARBARA CO., CAL. Carpinteria was established in 1863. (P/P: Unknown.)

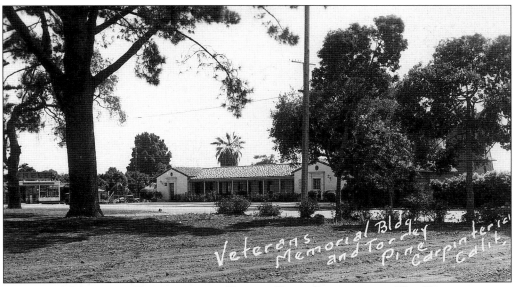

VETERANS' MEMORIAL BUILDING AND TORREY PINE, CARPINTERIA. The Torrey pine was transplanted from Santa Rosa Island in 1890. It occurs naturally only in a small area north of San Diego, California, and on Santa Rosa Island in the Santa Barbara Channel. (P/P: Unknown.)

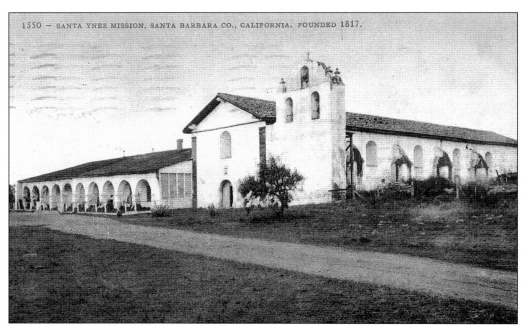

Santa Ynez Mission, Santa Barbara Co., California. This mission was founded in 1817. (P/P: Edward H. Mitchell, San Francisco, No. 1550; postmark: May 1911.)

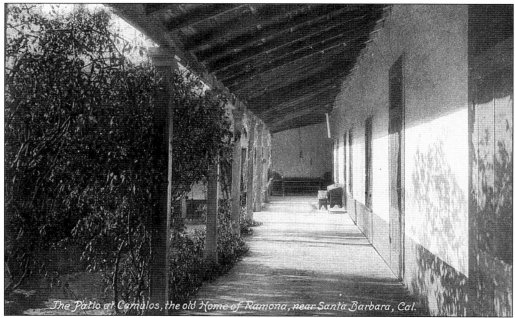

The Patio at Camulos, the Old Home of Ramona, near Santa Barbara. (P/P: M. Rieder, Los Angeles, No. 4196; made in Germany.)

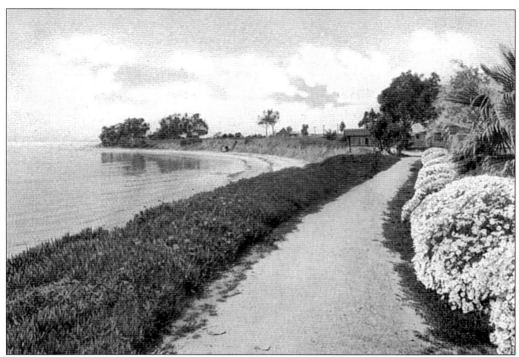

VIEW OF MIRAMAR BEACH LOOKING WEST, NEAR SANTA BARBARA. (P/P: Adolph Selige Co., St. Louis, Leipzig, Berlin, No. 3338; printed in Germany; undivided back; postmark: October 1908.)

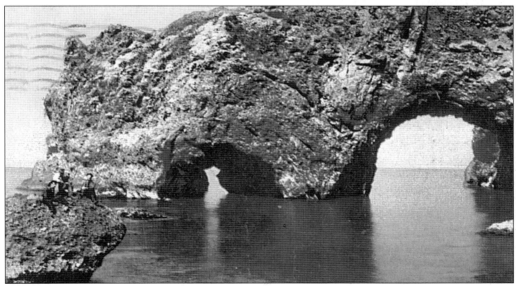

ARCHES ON ANNACAPPA ISLAND, SANTA BARBARA. (P/P: Detroit Publishing Co., No. 9118; undivided back; postmark: March 1907.)

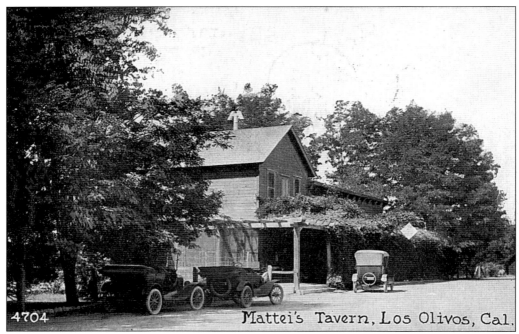

Mattei's Tavern, Los Olivos. (P/P: Pacific Novelty Co., San Francisco & Los Angeles, No. 4704; postmark: August 1940.)

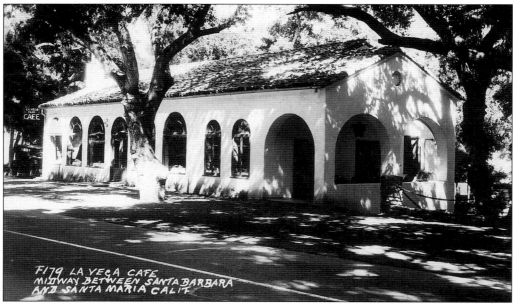

La Vega Café, Midway between Santa Barbara and Santa Maria, California. (P/P: Unknown, No. F 179.)

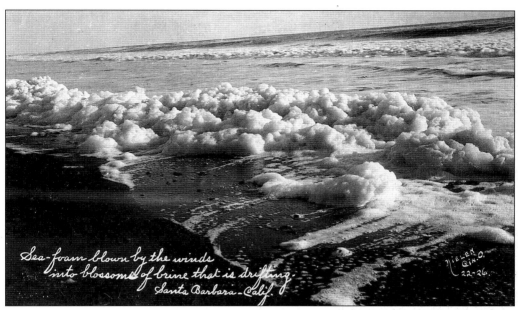

SEA FOAM IS BLOWN BY THE WINDS INTO BLOSSOMS OF DRIFTING BRINE IN SANTA BARBARA. (P/P: Unknown.)

This book is dedicated to my wife, Shirley L. Heckman, who wonders whether deltiology is a hobby or a disease.

"AT SANTA BARBARA"

COME SIT BESIDE ME ON THE SAND, AND FAR ACROSS THE SEA
WHERE SUNSET PAINTS THE WINGS OF NIGHT, WE'LL DREAM OF A DAY TO BE.
DRINK WITH ME, LOVE, THE SALT SEA AIR, BLOWN FROM THE SILVER SAND.
LOOK WITH ME, LOVE, UPON ITS FACE, THE FACE WHICH TELLS NO TALES
OF THE HOPES IT HOLDS AS ITS MUSIC TOLLS HERE WHERE DAYLIGHT FAILS.
OUT O'ER THE DEEP, THE SEABIRDS WHEEL AND THE SAILS OF THE SHIP ARE SPIED,
THEY FLASH IN THE SUN AND ONE BY ONE FADE IN THE DISTANT WIDE.
HERE WHERE THE TALL GRASS WAVES ABOUT, HID BY A DUNE OF GRAY,
WE'LL PLEDGE AGAIN UPON THE SAND THE LOVE OF YESTERDAY.

—PERCY A. MONTGOMERY

Sunset, the Magazine of the Pacific and all of the Far West
26(May 1911): 543.

Index of Publishers and Photographers

Albertype, Postcards of Quality, Brooklyn, NY 46, 63
[Artura] 20, 36, 39, 40, 41, 46, 71
Art Litho Co., San Francisco 18
Benham Co., Los Angeles 67, 73, 80, 111
Berkey, M.F., Santa Barbara 27, 35, 41, 77, 82, 86, 87, 90, 96, 99, 106, 110, 111, 113, 118, 119
Berkey & McGuire, Santa Barbara 62, 64
Brock-Higgins Photo 93
California Sales Co., San Francisco 33, 84
Carlin Post Card Co., Los Angeles 12, 28, 81
Carpenter, M.V. 58
Charlton, E.P., Los Angeles 16
Collinge, J.W., Santa Barbara 37
Detroit Publishing Co. 6, 16, 23, 24, 31, 34, 56, 74, 77, 79, 95, 100, 115, 125
Frashers Photo, Pomona 66
Gerlock, G.W., Santa Barbara 54
Kashower, Robert, Los Angeles 68
Kropp Co., E.C., Milwaukee, WI 32
Longshaw Card Co., Los Angeles 4, 17, 68
Martin, Fred E.W., Pasadena 65, 105
Mitchell, Edward H., San Francisco 9, 25, 26, 56, 60, 61, 78, 79, 82, 88, 97, 107, 124
Neuner Co., Los Angeles 33, 43
Newman Post Card Co., Los Angeles 10, 11, 19, 25, 27, 28, 29, 34, 35, 80, 85, 87, 101, 121
Osborne's, Santa Barbara 2, 38, 39, 42, 44, 57, 59, 61, 63, 66, 72, 84, 100, 118
Pacific Novelty Co., San Francisco 12, 15, 83, 93, 99, 117, 126
Ponto, Theodore R., Los Angeles 69
Reed Studio, NH 42, 96
Rieder, M., Los Angeles, Dresden, Leipzig 13, 14, 15, 21, 22, 23, 29, 30, 37, 55, 60, 62, 69, 73, 75, 76, 81, 85, 88, 90, 91, 92, 94, 98, 101, 102, 103, 104, 105, 112, 114, 115, 116, 120, 124
Scherer Printing Studio Press (for Ramona Bookstore) 48
Selige Co., Adolph, St. Louis, Leipzig, Berlin 22, 75, 97, 108, 109, 110, 116, 122, 125
Simplicity Co., Grand Rapids, MI 64
Souvenir Publishing Co., Los Angeles & San Francisco 76, 102
Tanner Souvenir Co., New York 20
Tichnor Brothers, Boston & Los Angeles 17
Western Publishing & Novelty Co., Los Angeles 32, 40, 59, 67, 72, 74, 86, 104, 112, 113, 117, 119, 120